Mexican American Baseball in Orange County

Who would have known
There was a hot dog eating sense
A *torta* sandwich sense with *jalapeños*
And a peanut eating sense
All brought together by
The games and our sense of baseball

A batting sense
A catching sense
A running sense
And our competition sense

La familia always came along
To watch their *m'ijos* play. To watch
Their brothers, sisters, uncles and parents

The "bosses" let us play,
Perhaps believing there was no reason to fear,
We would never compete further than our home

But home was a plate
And we loved running through it
Home was our parents
And we showed them . . .
That the distance from the pitching mounts
To home plate was the same in every diamond
We knew it . . . 'cause we had a sense for baseball.

—Alejandro Moreno

FRONT COVER: Ray Ortez played baseball and softball in Anaheim during the 1930s. Besides playing ball in high school, he went on to play for teams in Arizona and Utah. In his early years, Ray G. Ortez, his father and manager of the Anaheim Merchants, coached him. (Courtesy of Monica Ortez.)

COVER BACKGROUND: Members of the Road Kings from Colonia 17th (Santa Ana and Garden Grove) began playing ball with the Catholic Youth Organization and developed into a car club; the group later became a baseball team. This photograph is from a 1952 championship game. (Courtesy of Richard Méndez.)

BACK COVER: Under the direction of coach Félix Gómez, the Aces, shown here in 1950, created a baseball field in a dirt lot. There, they thrilled residents from all three Mexican American neighborhoods in La Habra on Sunday afternoons with softball matches against other local girls' teams. (Courtesy of Rosie Gómez.)

MEXICAN AMERICAN BASEBALL IN ORANGE COUNTY

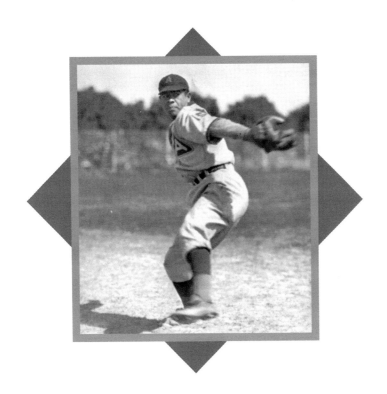

Richard A. Santillán, Susan C. Luévano,
Luis F. Fernández, and Angelina F. Veyna
Foreword by Gustavo Arellano

ARCADIA
PUBLISHING

Copyright © 2013 by Richard A. Santillán, Susan C. Luévano, Luis F. Fernández, and Angelina F. Veyna
ISBN 978-0-7385-9673-0

Published by Arcadia Publishing
Charleston, South Carolina

Printed in the United States of America

Library of Congress Control Number: 2012949753

For all general information, please contact Arcadia Publishing:
Telephone 843-853-2070
Fax 843-853-0044
E-mail sales@arcadiapublishing.com
For customer service and orders:
Toll-Free 1-888-313-2665

Visit us on the Internet at www.arcadiapublishing.com

A Teresa, mi corazón y alma—Richard

To my husband, Al Molina, whose love of the game provided the opportunity for me to be part of this amazing world—Susan

Con amor y gratitud a Fernando, Carmen, Darío, Alejandro y Verónica por su apoyo en cada etapa de mi vida—Luis

In gratitude to all the teachers who educated these beisbolistas—Angelina

CONTENTS

Foreword		6
Acknowledgments		7
Introduction		8
1.	From Orange Groves to Baseball Fields	9
2.	Powerhouses of the North	27
3.	Home Runs for the Community	49
4.	The Golden State	71
5.	Coast to Coast	91
6.	Field of Dreams	109
Bibliography		126
Latino Baseball History Project Advisory Board		127

FOREWORD

When voters finally elected Bert Blyleven to the Hall of Fame in 2011, it was not just a vindication of the former pitcher's talent, but also of legendary scout Jesse Flores. Flores discovered Blyleven at Santiago High in Garden Grove as yet another prospect in his long list of talents that Flores found from local high schools and the minors. He developed his ability for gauging talent not so much from his stint as a pitcher in the majors during the 1940s, but from his "home" diamond, Orange County, where young men like him, who just wanted to play ball, represented their barrios in segregated leagues with little hope of advancing further in their careers, and yet they played.

Mexican American Baseball in Orange County is the first-ever book dedicated to this story, a must-read for fans of baseball, regional, and ethnic histories. Compiled by Chicano and Chicana scholars, it is a study that is long overdue and one deserving of an Angels home-stand giveaway (along with bobbleheads!). Within these pages, you will read riveting stories of legendary teams and players, both men and women, and you will learn how the all-American pastime proved so crucial to the formation of a cohesive Mexican American identity in Orange County and beyond.

Although de facto segregated baseball leagues had largely ended by the 1950s, their pioneering heirs continue today. Arte Moreno became the first Mexican American owner in professional sports when he bought the Angels in 2003. Orange County resident Alfonso Márquez became the first Mexican-born major league umpire in 1999. Mexican Americans represented Orange County as our most recent Little League World Series champs, and some are currently playing in the "bigs."

Every weekend, baseball diamonds across Orange County are packed with today's modern-day "barrio nines," teams representing Mexican ranchos, where immigrants and their sons still play for the love of the game and the hope that, like Flores, one of them will make it.

Gustavo Arellano is *OC Weekly* editor and author of the column ¡Ask a Mexican! His limited baseball abilities exiled him to a lifetime of playing right field and the bench.

ACKNOWLEDGMENTS

The mainstay of this project to recover the history of Mexican American baseball in Orange County is due to the work of the Latino Baseball History Project at California State University, San Bernardino (CSUSB). Others who supported this effort include the following individuals and staff at the CSUSB John M. Pfau Library: Dean César Caballero and Sue Caballero; Jill Vassilakos-Long, head of archives and special collections; Iwona Contreras; Ericka Saucedo; Amina Romero; AnneMarie Hopkins; Carrie Lowe; Mackenzie Von Kleist; Karina Echave; Manny Verón; and Brandy Montoya.

 The authors are grateful to the many players and their families who lent their time, effort, precious family photographs, and oral histories to ensure that the struggles and triumphs of the Mexican American communities in Orange County are not forgotten by future generations. We especially want to thank Jim Segovia, who was a key liaison with the players and their families and who hosted, along with his wife, Gloria, numerous events at their home to facilitate the completion of this work. The book also benefited from the larger network of community members and organizations that donated time and energy to this project, including the following: Al Molina, Max Molina, Marty Grajeda, Frank Mendoza, Maria Lavalle, José G. Felipe, Monica DeCasas Patterson, Roberto Meléndez, Joe Juárez, Enrique Zúñiga, Damien and Frank Muñoz, Benjie Gómez, Rosie Gómez, Richard Lugo, Bea Dever, Mary García, Helen Parga-Moraga, Fernando Olivares, Alejandro Moreno, Gustavo Arellano, Ron González, Abel Becerra, Jane K. Newell at the Anaheim Heritage Center, the Southeast Chicago Historical Society, the Texas A&M University-Corpus Christi Bell Library, the Fullerton Public Library, the Santa Ana Public Library, and Lizeth Ramírez at the Orange Public Library. Any uncredited photographs appear through the courtesy of the Latino Baseball History Project.

 This work was fortunate enough to have the guidance of editors Michael Burgess and Mary Wickizer Burgess. We are grateful to Mark Ocegueda for his critical assistance with layout guidelines. The authors also wish to extend their special appreciation to graduate researcher Christopher Doctor and Darío Fernández for their assistance. Last but not least, we thank Arcadia Publishing and our editors Elizabeth Bray and Jeff Ruetsche.

INTRODUCTION

High rates of Anglo migration into Orange County during the latter half of the 19th century forced Mexicans into barrios or *colonias*, ethnic enclaves, that socially and politically separated Mexicans from the newly formed Anglo sections of cities and towns. This overt form of segregation reinforced the use of Spanish language, religious practices, and social rituals and further strengthened Mexican neighborhoods and family ties.

Throughout the first half of the 20th century, Mexicans continued to cross the realigned border into *el norte*, bolstering their standing in the United States, beginning with refugees fleeing the Mexican Revolution of 1910 as well as contract labor under the Bracero Program that lasted without challenge for decades. The steady flow of migratory workers kept Orange County's agricultural industry flourishing as a multimillion-dollar economy. Not without strife, Orange County dealt with the devastating Citrus Strike of 1936. Mexican work hands, 2,500 strong, rose up against landowners demanding higher wages, better working conditions, and the right to unionize. Historian Carey McWilliams called the vigilantism and terror campaigns by the citrus owners against the predominately Mexican strikers the toughest violation of civil rights in the nation.

To counteract labor tensions, landowners began to sponsor *béisbol*, or baseball, as a means of keeping their labor pool satisfied and productive. But Mexican workers took it a step further, transforming the game of béisbol into a multifaceted way to promote their own political agenda. Through béisbol, Mexicans acquired a new sense of solidarity and collaboration within their community. For women players, it was a way to defy the social mores of their times and make gains in the field of gender equality one base at a time. Sandlot teams propelled youngsters into semiprofessional, professional, and military teams. Barrio teams, largely sponsored by local shop owners and civic organizations, advanced cultural pride. In segregated schools, béisbol became part of the process to "Americanize" Mexican children and instill dominant cultural values.

Mexican American Baseball in Orange County highlights these ethnic communities' contributions to baseball history. More importantly, it demonstrates how baseball and softball players with extraordinary talents on the diamond field were able to translate their talents into the field of justice and equality. As baseball players and leaders of oppressed communities of Mexican Americans, they fought segregation on the diamond field and in the social, cultural, and political arena. They pioneered legal challenges against school and housing segregation that the US Supreme Court later affirmed in *Brown v. Board of Education* and *Shelley v. Kraemer*. Although many of those early players have now passed on, one can find their footprints in Orange County's parks, schools, and baseball fields bearing their names. With the swing of the bat, with the steal of a base, and with the grip of the glove, they made advances in civil rights to ensure that their sons and daughters could simply play.

FROM ORANGE GROVES TO BASEBALL FIELDS

El béisbol, as America's pastime was called in Mexican American barrios, was played throughout North and South Orange County, from La Habra to Santa Ana to San Juan Capistrano. In addition to béisbol, cultural practices, such as the religious procession in El Campo Corona, the Fiestas Patrias celebration of Mexican Independence on Diez y Seis de Septiembre, and active participation in civic organizations like La Sociedad Progresista Mexicana, further enhanced cultural and societal cohesion within the Mexican American community.

Béisbol thrived in the sandlot, labor- and business-sponsored, semiprofessional, and amateur matches throughout the county. Jesse Flores began playing with Los Juveniles in El Campo Colorado of La Habra before being drafted into the majors. In La Jolla, the boys versus girls match became a true battle of the sexes. Competing teams, like Tom Múñoz's Placentia Merchants and Blas Marrón's La Fonda Stars, were sponsored by local businesses and organizations. In El Modena, Ignacio and Silvino Ramírez played softball on the field umpired by their father, Lorenzo Ramírez, after their family's successful legal challenge against school segregation. After serving in the military during World War II, Celso DeCasas came home to Atwood where he formed a softball team, the Atwood Giants, and served as the team's manager with his siblings as team members. Semiprofessional women's teams, like the Santa Ana Queens (where Helen Parga was the sole Mexican American player), provided an opportunity for players to play for pay and inch forward toward social integration. Friendly amateur matches, such as those between the Saldívar brothers and John Soto, were played out during social gatherings in places like Irvine Park. In San Juan Capistrano, béisbol served as a community event, played in the center of town, which allowed players and fans alike the opportunity to organize politically and socially.

Béisbol proved much more than a game, it brought to the playing field an array of social, economic, and political opportunities for the community. Orange County teams often intermingled in baseball matches with nearby Los Angeles and Inland Empire teams expanding their networks via the all-American pastime, out of their barrios and into other counties, states, and ultimately the nation. Play ball!

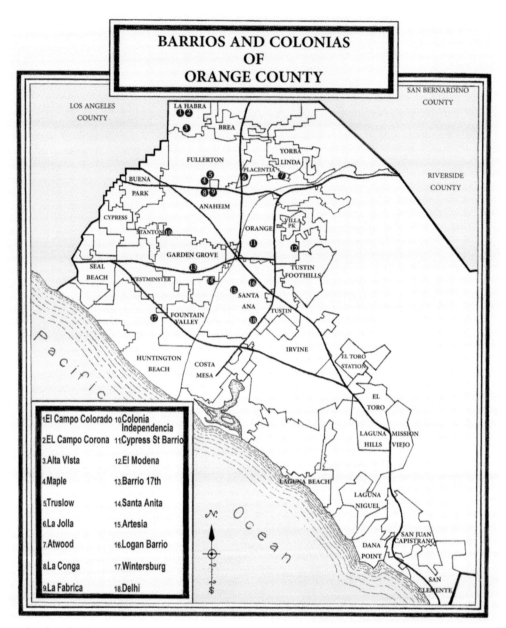

In the first half of the 20th century, Campo Colorado/Campo Corona (La Habra), Truslow (Fullerton), Atwood (Placentia), Colonia Independencia (Anaheim), El Modena (Orange), Logan (Santa Ana), and many other barrios and colonias were part of an informal league of well-organized and highly skilled teams that played throughout Orange County and into Los Angeles and San Bernardino. While recognizing that many other significant Mexican American communities also existed within Orange County, this map highlights barrios and colonias where formal baseball and softball teams were most prominent. (Courtesy of Fernando Olivares.)

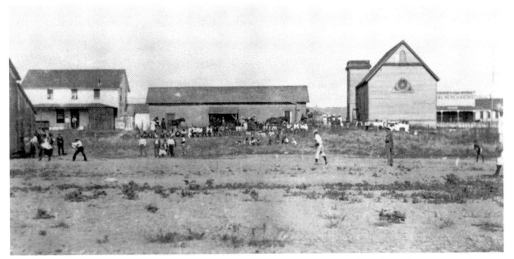

Baseball was a community event in San Juan Capistrano, often played at the center of town, which allowed players and their fans to gather and socialize. This 1916 photograph shows locals rallying around a game. The General Merchandise Store (far right), located on Camino Capistrano, housed the post office headed by postmaster Fidel Sepúlveda. The Sepúlvedas were a prominent land grant family; José Sepúlveda was granted title to Rancho San Joaquín in 1837. (Courtesy of the San Juan Capistrano Historical Society.)

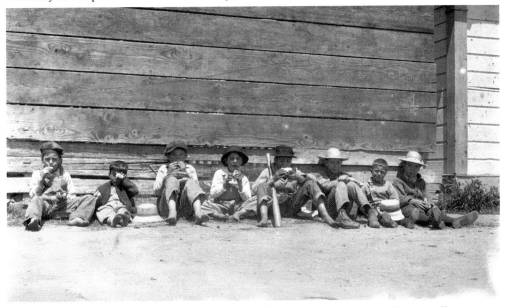

Around 1917, a group of boys sit on the side of a building, eating and resting after a sandlot game in San Juan Capistrano. Some of the boys are barefoot, which was a common sign of poverty in many barrios considering their parents worked for low wages in agricultural fields and packinghouses. Rampant poverty did not deter youth from playing baseball since the game only required a ball and a bat (sometimes a stick) and, with creativity, handmade gloves. (Courtesy of the San Juan Capistrano Historical Society.)

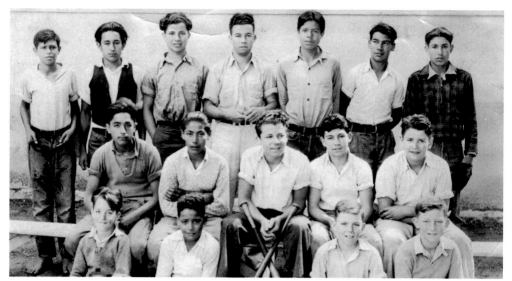

The 1931–1932 San Juan Capistrano School baseball team included (second row) Aciano Ávila, fourth from left; and Pancho Forster, a descendant of the Ávila family, far right; (third row) John Manríquez, far left; George Ávila, center; and Art Daneri, third from left. The Ávila family was one of the original land grantees in Orange County and one of the town's founding families. Their presence in Southern California dates back to 1781 with their arrival in El Pueblo de Nuestra Señora la Reina de los Ángeles (Los Angeles). (Courtesy of Pat Forster.)

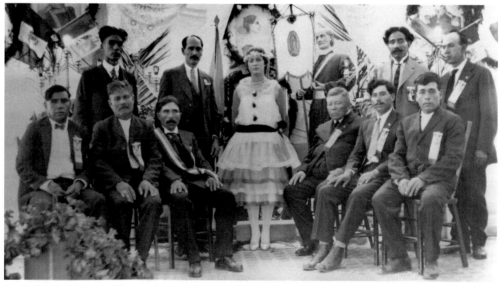

La Habra held one of the earliest and most elaborate Diez y Seis de Septiembre celebrations in North Orange County. This photograph, taken at El Campo Colorado on September 16, 1921, features La Reina de las Fiestas Patrias queen Ernestina García, accompanied by men of the Fiestas Patrias Organizing Committee. Most of the residents from El Campo Colorado and its sister barrio, El Campo Corona, were citrus workers employed by the La Habra Citrus Association. (Courtesy of Enrique Zúñiga.)

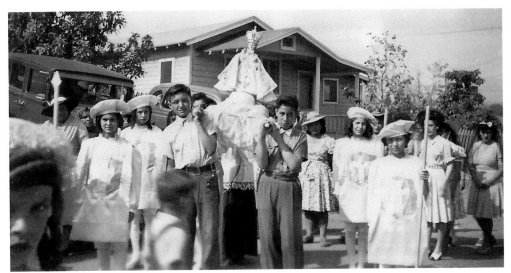

Religious rites in El Campo Corona were a large part of daily life. Pictured here around 1930 are young men and women participating in a religious procession with a statue of El Niño de Praga being carried to the Mission Church of Our Lady of Guadalupe on Fourth Street, the main street in El Campo Corona. The church, built by local residents, also served its neighboring barrio, El Campo Colorado. (Courtesy of Al Molina.)

Pictured at Irvine Park in 1955 are, from left to right, Nicolás Saldívar, Jesús Saldívar, John Soto Sr., and Aurelio Saldívar from Santa Ana's Logan barrio. They often played the "great American pastime" on Sunday afternoons after church. During the Great Depression, the United States–born Saldívar brothers were unconstitutionally repatriated to Durango, Mexico. Jesús Saldívar returned to the United States as a married man in 1949, where he continued playing amateur baseball for the love of the game. (Courtesy of Teresa Saldívar.)

In the 1930s and 1940s, Orange County's Sycamore Flats, located alongside the Santa Ana River on the border of Orange and Riverside Counties, served as a popular weekend picnic spot for Mexican American families. *Jamaicas*, festive fundraiser parties sponsored by civic organizations, were common occurrences. Sycamore Flats was also a place where weekend family baseball matches were common occurrences. (Courtesy of Gene Rodríguez.)

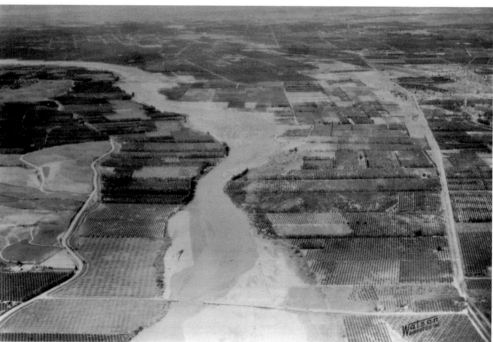

The Santa Ana River flood of 1938 turned one-third of Orange County, from Yorba Linda to Newport Beach, into a shallow lake. The low ground levels of Atwood and La Jolla in Placentia were the most impacted, as pictured here. Out of 32 casualties in the area, 16 lived in Atwood and La Jolla, and one little girl's body was found with her head caught in the limbs of an orange tree. (Courtesy of Orange County Archives.)

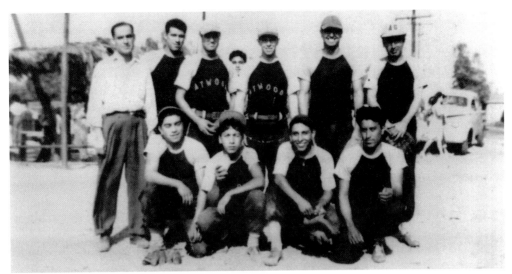

Pictured in Atwood barrio in Placentia at the end of World War II, Celso DeCasas (far left in dress clothes) formed a softball team called the Atwood Giants and became the team's manager. The Atwood Giants maintained a friendly rivalry with the Eastside Club of Fullerton, and many players from both teams became lifelong friends. To Celso's immediate left is his brother-in-law Henry Martínez. In the first row at far right is Apolinar Ramírez. (Courtesy of Monica DeCasas Patterson.)

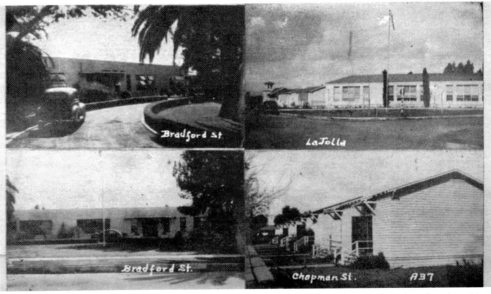

This postcard pictures La Jolla and Chapman Hill Mexican Schools along with the white Bradford School in Placentia. Segregated Mexican schools were created in the early 1900s due to inferior ideas about Mexican character and aptitude. Segregated schools were often housed in makeshift buildings in poor condition and had inadequate supplies and outdated curricula. After 1952, Valencia High School in Placentia was integrated, allowing some Mexican students to attend and excel in its academic curricula and athletic programs. (Courtesy of Ray Reyes.)

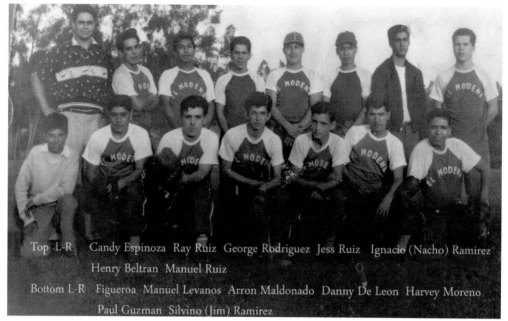

Top L-R Candy Espinoza Ray Ruiz George Rodriguez Jess Ruiz Ignacio (Nacho) Ramirez Henry Beltran Manuel Ruiz
Bottom L-R Figueroa Manuel Levanos Arron Maldonado Danny De Leon Harvey Moreno Paul Guzman Silvino (Jim) Ramirez

Around 1950, Silvino and Ignacio Ramírez played softball for El Modena; their father, Lorenzo Ramirez, was the umpire. They played on the El Modena diamond field, which served as a divide between Lincoln Mexican School and the white Roosevelt School. In 1947, Silvino and Ignacio's parents, Lorenzo and Josefina Ramírez, along with the Méndez, Palomino, Estrada, and Guzmán families, successfully sued five Orange County school districts on behalf of their children in *Méndez, et al. v. Westminster School District, et al.*, ending de jure school segregation in Orange County. (Courtesy of Silvino Ramírez.)

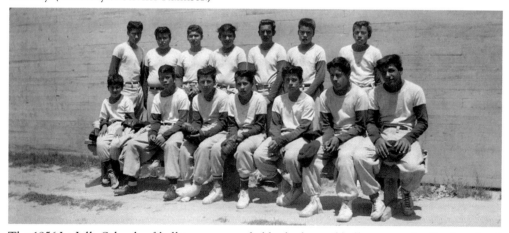

The 1956 La Jolla School softball team was probably the last softball team to play for the school since students were being sent to Kraemer Junior High and Valencia High School as school desegregation began to take place. Pictured are, from left to right, (first row) unidentified, Rosalio García, Arnold Puentes, unidentified, Joe Martínez, Freddie Martínez, and Fred Dorado; (second row) Bobby Pérez, Luís Pineda, Blas Solórzano, Danny Acosta, Joe Covarrubias, Raúl García, and Bobby García. (Courtesy of the Gualberto J. Valadez family.)

Domingo DeCasas attended La Jolla Grammar School for Mexican students and participated in athletics under the direction of coach Gualberto J. Valadez. At Valencia High School, he excelled in baseball until joining the US Navy during World War II. After the war, he and his brothers played with the Atwood Giants. Domingo and brother Joe continued playing softball throughout the county, and Domingo played for several years in the National Niteball League, a professional softball league in Orange County. (Courtesy of Monica DeCasas Patterson.)

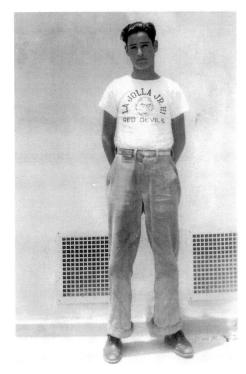

Frank Rangel vividly remembers when sheriffs infiltrated the orange groves where he worked, shotguns in hand, to intimidate strikers during the Citrus Strikes of 1936. That same year, Rangel played baseball for Valencia High in a California Interscholastic Federation (CIF) game against San Diego's Hoover High. One of his opponents was a tall, lanky kid who went on to become one of the greatest hitters of all time, Ted Williams. Later, Rangel joined the Army during World War II. While stationed in the Philippines, he played for the Manila Dodgers against such notables as Joe Garagiola, Ray Lamanno, and Dominic DiMaggio. (Courtesy of Frank Rangel.)

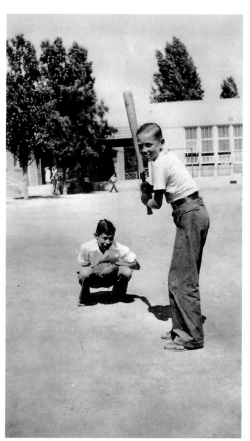

Ernest Johnson (at bat) and Frank Muñoz (catcher) are pictured here in 1937 at Maple Elementary School in Fullerton. Sports allowed a space for youth from all ethnic backgrounds to interact on the field even when societal prejudice did not always condone social interactions off the field. (Courtesy of Frank Muñoz.)

Pictured around 1920, Robert Rodríguez plays baseball in a dirt-filled lot in Truslow, a barrio adjacent to the Sunnyside Addition in Fullerton, California. The two neighborhoods were yards apart, yet racial-restrictive covenants barred Mexicans from buying property in Sunnyside. During World War II, agricultural labor was in such great demand throughout the United States that communities of color used labor as a leverage to mount challenges against gender and racial discrimination on the home front. (Courtesy of Gene Rodriguez.)

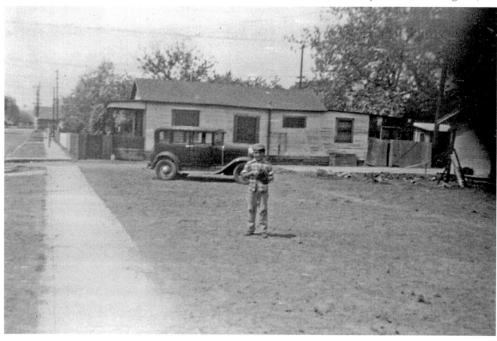

Jesse Flores came from Mexico at an early age, grew up in La Habra's El Campo Colorado, and attended Wilson and Washington Mexican Schools. He played sandlot baseball with Los Juveniles and signed with the Los Angeles Angels of the Pacific Coast League in 1938. His Major League Baseball debut was with the Chicago Cubs (1943–1947). He later played with the Philadelphia Athletics and the Cleveland Indians, where he ended his career in 1950. Jesse Flores pitched against all the greats in baseball, including Yogi Berra.

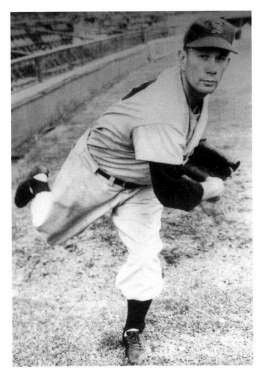

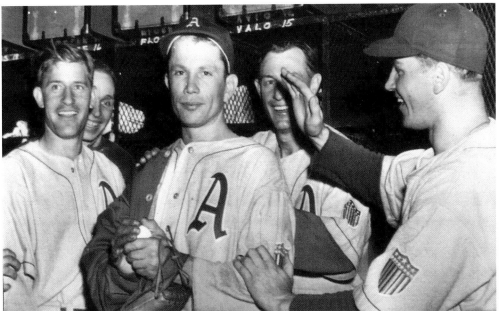

After ending his baseball career in 1950, Jesse Flores returned to La Habra, California, where he tried unsuccessfully to purchase a home on the Anglo side of town. When Flores complained to the city's Republican leaders, they asked him to help them garner the Latino vote in their upcoming elections and promised he would be allowed to purchase the home he wanted as "payment." Flores refused their offer and instead bought a home in the better part of the barrio.

Helen Parga plays baseball with her family during a weekend outing at Sycamore Flats in 1936. Parga began playing softball two years earlier while attending Franklin Grammar School in Santa Ana. When a fifth-grade pitcher broke his arm during the playoffs, school staff members wanted Parga to play as substitute pitcher but were forced to obtain special permission from the school board before she was allowed to pitch against an all-boys' team. (Courtesy of Helen Parga-Moraga.)

In the 1940s, Helen Parga played for the Lionettes of Orange. Later, Parga worked eight hours a day packing oranges, then practiced nights at Eddie West Field with the Santa Ana Queens. At an away game in Phoenix, Arizona, the Queens made a pit stop at a diner. Parga, the only Mexican on the team (second row, fourth from right), was told she could not eat with her teammates and was sent to a segregated waiting room. When her teammates learned this, they walked out of the diner in protest. (Courtesy of Helen Parga-Moraga.)

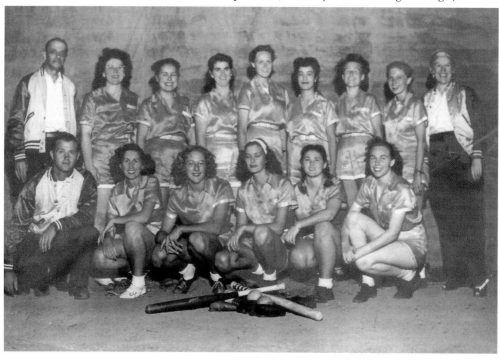

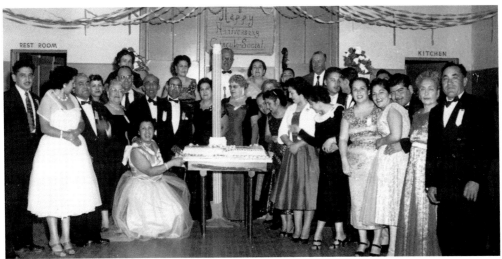

El Círculo Social (a social organization) is shown here celebrating its anniversary around 1957. Important community leaders in attendance included members of La Sociedad Progresista Mexicana, a mutual aid society that held fundraisers such as dances to pay for burials of members and to help fund other good causes. Also present are Celso DeCasas, president of Placentia's Progresista Legion, La Gran Tenochtitlán, No. 16; Plácido and María Veyna, owners of Pete's Market in Anaheim; and Eduardo and Juanita Negrete, from Negrete's Market in Fullerton. (Courtesy of Angelina F. Veyna.)

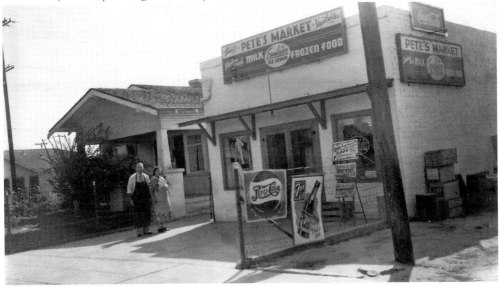

Local *tienditas* (or small markets) provided diverse goods familiar to local Mexicanos. In the 1950s, Pete's Market of Anaheim sold clothing and tools necessary to workers in the citrus orchards and members of the local *campo de braceros*. Tienditas provided money order services and extended credit to its customers, a practice not generally followed with Mexicans in Anglo stores. Tiendita owners often became respected leaders of the community, and many of them sponsored local softball and baseball teams bearing the name of their business. (Courtesy of Angelina F. Veyna.)

Tom Muñoz managed the Placentia Merchants for 54 years (1936–1990). Home games were played at McFadden, Valencia, and El Dorado schools. Away games were in Los Angeles and San Bernardino Counties and in Tecate, Tijuana, and Ensenada (Mexico). Muñoz would ready the fields by going to the railroad yards in Atwood to get lye to stripe the field lines. On Saturday afternoons, he would sit in his yard with a bucket of baseballs and his eraser and, with help of his children and grandchildren, clean baseballs. (Courtesy of the Tom Muñoz family.)

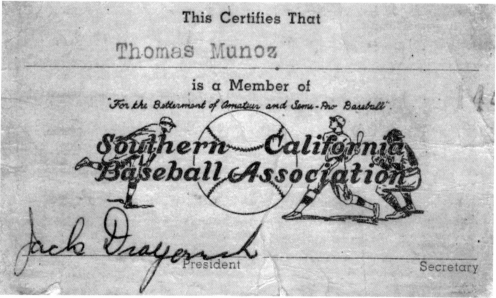

Under Tom Muñoz's leadership, the Placentia Merchants became the first Orange County team to enter the Southern California Baseball Association (SCBA). Once they had joined the association, the Placentia Merchants took on all teams, including African American teams, while the Anglo teams refused to play because of racial segregation, which existed inside and outside the diamond field. Tom Muñoz's lifelong motto was "God first, family second, baseball third." (Courtesy of the Tom Muñoz family.)

Tom Muñoz was picking foreman at the Placentia Mutual Orange Association and founder and manager of the Placentia Merchants baseball team. Pictured are Nick García (left) and Tom Muñoz (right) in the 1940s. Muñoz arranged games, found sponsors, and provided transportation. Aurora, Muñoz's wife, sold *raspados* and sodas to help with the purchase of equipment, and in 1942, after a successful round of fundraising, the Merchants were outfitted with new uniforms. (Courtesy of the Tom Muñoz family.)

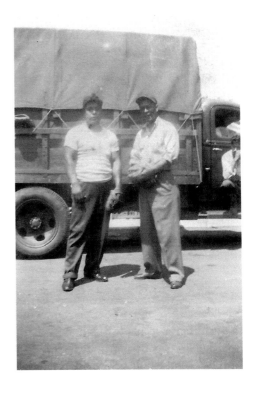

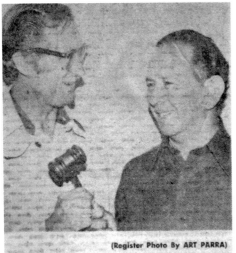

(Register Photo By ART PARRA)

NEW BASEBALL PRESIDENT — Blas Marron (right) received the gavel as president of the 32-team Southern California Baseball Assn. from outgoing prexy Jim Bell. Installation ceremonies took place at La Fonda Restaurant in Santa Ana. Marron, a resident of Santa Ana and associated with the league for 25 years as a player and manager, has seen the league expand as far north as Ventura. Orange County is represented by two teams, playing each Sunday afternoon, Placentia Merchants and La Fonda Stars.

In 1973, Blas Marrón was named president of the Southern California Baseball Association (SCBA). Marrón and Tom Muñoz were not only good friends, but also baseball rivals as managers of two of Orange County's powerhouse teams, La Fonda Stars and the Placentia Merchants. Local newspapers headlined one encounter between the rival teams: "Stars, Merchants Clash on Sunday." Despite their friendly rivalry, Marrón and Muñoz carpooled every Monday night to the SCBA meetings in Los Angeles. (Courtesy of the Tom Muñoz family.)

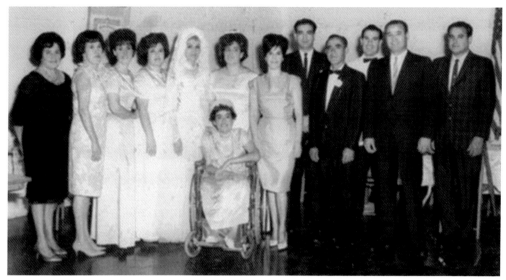

From the 1930 through the 1960s, the DeCasas brothers, Celso, José, Domingo, Ricardo, and Henry, participated in baseball and softball teams in Orange and Los Angeles Counties. Members of the DeCasas family are, from left to right are Juana, Piedad, Julia, Margaret, Dolores (the bride), Antonia, Refugio (in wheelchair), Eliseo, Ricardo Jr., Celso, Henry, Domingo, and José. The DeCasas family, from Atwood in Placentia, survived the raging Santa Ana River flood of 1938, although one cousin, Tiburcia, perished. Celso DeCasas is credited with saving several lives from the wrath of the river. (Courtesy of Monica DeCasas Patterson.)

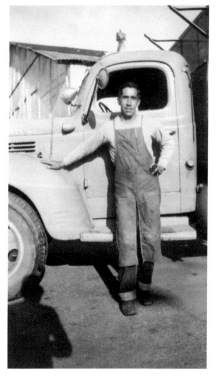

In 1943, Alex Bernal (pictured at left) and his wife, Esther, defended and won the right to own a home in the Sunnyside Addition in Fullerton, California. Their victory against the enforcement of racial-restrictive covenants was publicized in *Time* magazine and the *March of Time*. *Doss v. Bernal* served as legal precedent in housing segregation cases and was ultimately reaffirmed by the US Supreme Court in *Shelley v. Kraemer*. (Courtesy of the Bernal family.)

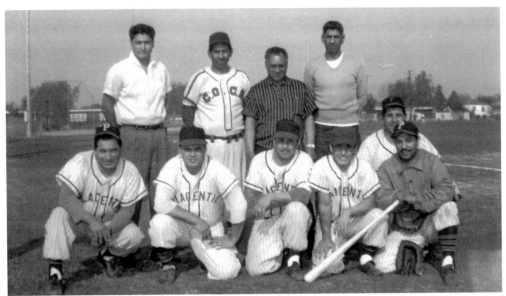

The Placentia Merchants became the 1953 Southern California regional team champs after defeating the Newport Beach/Costa Mesa team. Pictured here are, from left to right, (first row, players) Frank Gómez, Johnny Mount, Rudy Gómez, Danny Gómez, Manuel Gómez, and Marcelo Ledesma; (second row, coaches and managers) Ted Herrera, Carlos Felipe, Tom Muñoz, and José G. Felipe. Ted Herrera, a well-known pitcher who was born in Fullerton, pitched for Orange Coast College, Pocatello Bannocks (Idaho), Stockton Ports, Vancouver Mounties, Yakima Bears, and the Lubbock Hubbers between 1950 and 1956. (Courtesy of Monica DeCasas Patterson.)

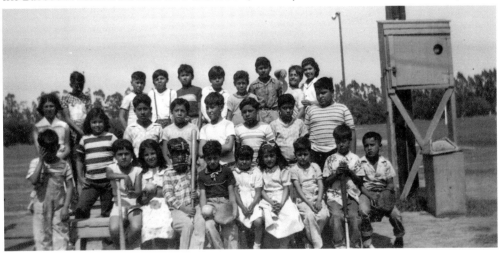

Around 1950, the La Jolla boys versus girls softball game was one of many programs coached by Gualberto J. Valadez and sponsored by the Placentia Recreation Department. Pictured are, from left to right, (first row) Alex Ortiz, fifth; and Larry Álvarez, ninth; (second row) Maricelo Venégas, first; Bobby Pérez, third; Bobby García, fourth; Rubén Montenegro, sixth; and Louis Pineda, eighth; (third row) Danny García, third; Raúl García, fifth; Blas Lozano, seventh; and Betty Venégas, ninth. (Courtesy of the Gualberto J. Valadez family.)

In 1953, Art and Bob Lagunas took their Pico Rivera's El Rancho High School baseball team to the playoffs. Later, both brothers played baseball at Orange Coast College (OCC). Seen in the picture above are Art (first row, third from left) Bob Lagunas (first row, fifth from left). After OCC, Art and Bob played ball at Cal State Los Angeles before they joined the military and played baseball in the service. Art played two years of military baseball while Bob played for the Fort Clayton Club in Panama. (Courtesy of Bob Lagunas.)

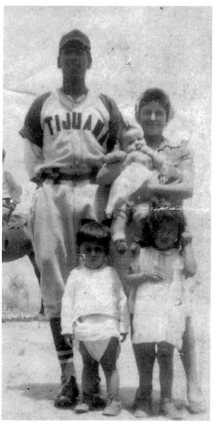

José G. Felipe of Placentia played for the Jabón Olivo team of Tijuana. He is pictured with his wife, Lupe, and three of his 17 children in 1946. Baseball for the Felipes was a family affair with some of the children accompanying him to various ballparks throughout Southern California. It proved exciting to leave the neighborhood and meet people from different areas and backgrounds. Weekends were often spent entertaining teammates and neighbors at their home on Walnut Street. (Courtesy of Monica DeCasas Patterson.)

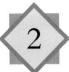

Powerhouses of the North

The citrus industry dominated North Orange County in the first half of the 20th century, creating a need for a large stable workforce. Families fleeing the uncertainty of civil war in Mexico settled in citrus labor camps by the thousands, filling the growing labor demands of the California Fruit Growers Exchange.

In an effort to ensure a stable and "Americanized" Mexican labor force, the citrus grower associations of La Habra, Richfield (Atwood), and Placentia organized, promoted, and sometimes sponsored segregated baseball teams. The sport, also popular in Mexico, caught on like wildfire!

During this period, Mexican communities confronted racial segregation and class discrimination that limited personal and community development. Baseball provided an outlet for social and recreational activities and brought together regional communities that came out in droves on Sunday afternoons to watch games played mostly on neighborhood dirt lots. More importantly for Mexican Americans, baseball presented an avenue to community empowerment. Despite the citrus owners' desires to exploit the game as a management pacification tool, baseball allowed players to take pride in their neighborhoods and cultural accomplishments. The game secured an opportunity to hone civic leadership and team-building skills and provided employment and economic prospects that opened doors for barrio players.

Jesse Flores, a star Juvenil Club pitcher, became a major league player and scout. Many members of Tom Muñoz's Placentia Merchants became civic leaders, due in part to leadership training provided by civic and educational pioneer Gualberto J. Valadez. Frank Muñoz of Fullerton, an outstanding athlete of his generation, would serve as head baseball coach at Westminster High School for over 20 years.

While baseball remained dominated by men, women excelled as well. Fullerton's Clara Águilar Engle taught baseball fundamentals to Maple youth in the 1930s. Women's softball teams, including the La Habra Aces and the La Jolla Kats, were popular during the late 1940s. Seferina Álvarez García became the first Mexican American president of the Fullerton College Women's Athletic Association in 1953.

With each generation of *beisboleros* (baseball players) going further than the last, this all-American sport aided Mexican Americans in their advancement toward an equal playing field.

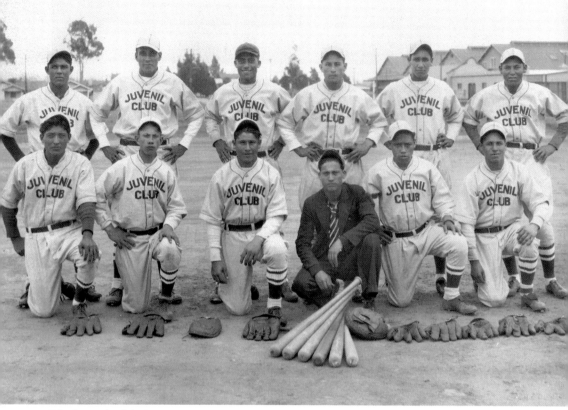

The Juvenil Club (1930) was composed of citrus workers from the La Habra Campo Corona and Campo Colorado barrios who purchased their own uniforms and equipment by sponsoring jamaicas (outdoor fairs with a dance). The team, which was active from the early 1920s and 1930s, played other Orange County barrio teams as well as Los Angeles–based African American (Richfield Nine) and Japanese American teams. Los Juveniles were considered one of the leading amateur baseball teams in North Orange County. (Courtesy of Al Molina.)

Jesse Flores (right) was a standout pitcher for the Juvenil Club (youth club) in the 1930s. Hundreds of Mexican American residents came out to watch Los Juveniles play on Sunday afternoons in the dirt lot next to the La Habra train station. The playing field and substandard housing seen in this image were typical of Mexican neighborhoods in Southern California. Jesse dropped out of school in the sixth grade to work in the citrus industry picking oranges. (Courtesy of Al Molina.)

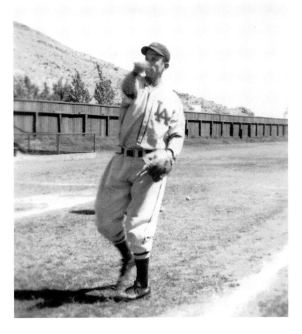

Jesse Flores was one of the first Mexican-born ballplayers to make it into the big leagues, developing his skills on the sandlots of La Habra. His family settled in El Campo Colorado, or Red Camp, a citrus workers' community, in 1923. He was the pride of the barrio when he signed to pitch for the Chicago Cubs farm team in 1938. Jesse is pictured here in his Los Angeles Angels uniform around 1940. He went on to have a 53-year career as a big league player and scout. (Courtesy of Al Molina.)

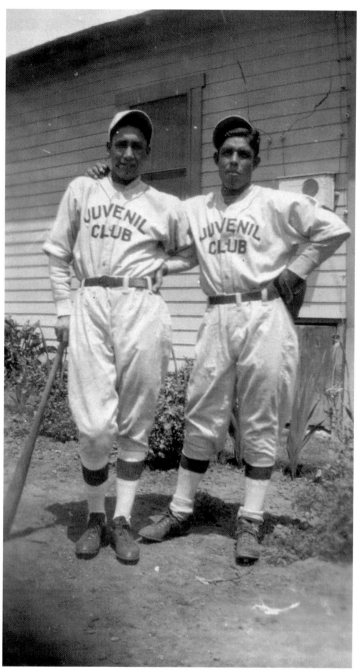

In this c. 1934 picture wearing Juvenil Club uniforms are, from left to right, first cousins Louie and Pete Molina. The Molinas settled in La Habra around 1921. The families of brothers Julio and Juan Molina lived next door to each other on Fourth Street, the main street of El Campo Corona, or "the Camp," as it was commonly known. The Camp housed citrus worker families employed by the La Habra Citrus Association. Barrio baseball inspired pride and self-respect in players and was a consolidating factor in community self-identification. (Courtesy of Al Molina.)

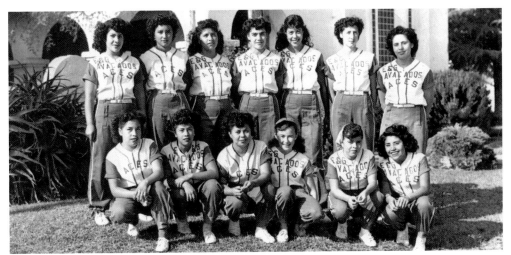

The Aces, pictured here in July 1950, were young women from the Campo Corona, Campo Colorado, and Alta Vista barrios in La Habra. Félix Gómez organized the team and served as coach. The team played in an open field that they cleaned up and made their own. Rosie Gómez, Amelia Zúñiga, and Rachel Zúñiga remember that barrio families, including their fathers, who enthusiastically supported their involvement, came out to see them play on Sundays and attended every home and away game. (Courtesy of Rosie Gómez.)

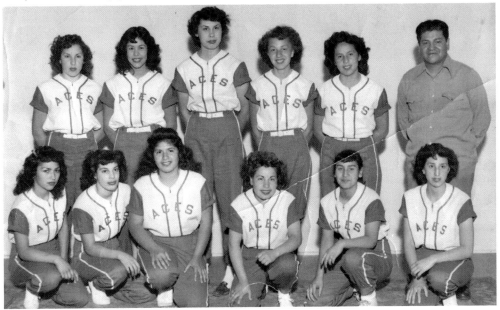

The La Habra Aces played sandlot softball together from 1947 to 1951. They practiced three to four nights a week until dark and passed the hat to purchase their first set of uniforms, pictured here in 1949. Team members are, from left to right, (first row) Mary Ruelas; Lucy Navarro; Evangelina Morales; Virginia De la Torre; Nellie Miranda; and Rachel Zúñiga, catcher; (second row) Magdalena Verduzco; Rosie García; Delfina Cordova; Sally Rodríguez; Amelia Zúñiga, pitcher; and coach Félix Gómez. Batboy Frank H. Zúñiga is not pictured. (Courtesy of Amelia Zúñiga.)

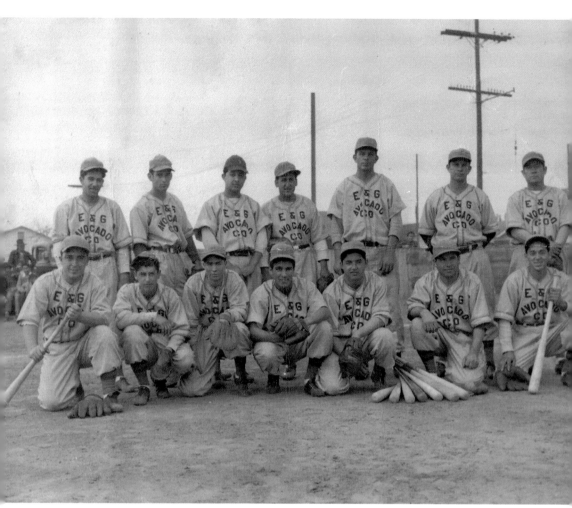

The Tigers or Los Tigres were a popular 1950s La Habra semiprofessional baseball team, started by Jesse Flores. Many players were the male descendants of his Juvenil Club teammates from the 1930s. The team practiced and played at Washington Elementary School. Pictured are, from left to right, (first row) Barney Padilla, Tony Padilla, Pancho Gutiérrez, Ray Uribe, Leonel Luna, John Guzmán, and Greg Gómez; (second row) Jesse Gómez, Art Samaniegro, Cruz Gómez, Moisés Zúñiga, Neche Flores, Jesse Flores, and Nacho Flores. (Courtesy of Benjie Gómez.)

Pictured here at the 1947 Southern California Junior Varsity Player of the Year awards dinner are, from left to right, Clara Águilar Engle, who was employed part-time by the City of Fullerton as the director of athletic programs at Fullerton's Maple School; her son Frank Muñoz, the evening's honoree; and Carmela González. Clara was a tough-as-nails, disciplined coach who is credited with teaching neighborhood youth the fundamentals of baseball, as well as other sports, during the 1930s and 1940s. She broke gender barriers in her role as a Mexican American female coach. (Courtesy Frank Muñoz.)

Fullerton's Maple School served a multiethnic neighborhood in the 1930s. Mexican families in the area were confined to living on Truslow Street until the landmark *Doss v. Bernal* decision made racially restrictive housing covenants illegal in the late 1940s. Pictured above is Maple School's 1936–1937 baseball team coached by Clara Águilar Engle. Some of the members include Bill Bundorf, Frank Muñoz, Ray Reyes, Shunro Nomura, Jimmy Goodwin, Peter Chang, Willie García, Raymond Marmelejo, Eddie Montoya, and Joe Carrisosa. (Courtesy of Frank Muñoz.)

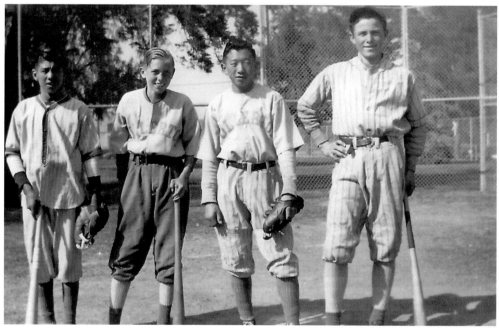

Pictured are members of the 1941–1942 Fullerton High School baseball team who hailed from Maple School, including, from left to right, Frank Muñoz, Ernest Johnson, Shunro Nomura, and Everett Simpson. The Nomura family and over 110,000 other Japanese Americans and Japanese who lived on the West Coast were sent to war relocation camps in 1942 after the bombing of Pearl Harbor. Executive Order 9066 authorized the internment for the duration of the war. (Courtesy of Frank Muñoz.)

After serving in World War II as a combat infantryman and parachutist and playing college and semiprofessional baseball, Frank Muñoz signed to play with the Fresno Cardinals, the St. Louis Cardinals' minor league team, for one year (1951). His unsigned 1952 National Association of Professional Baseball Leagues contract is displayed at right. The Cardinals offered $225 per month for Frank's services. Frank went on to have a successful career teaching and coaching at Westminster High School. (Courtesy of Frank Muñoz.)

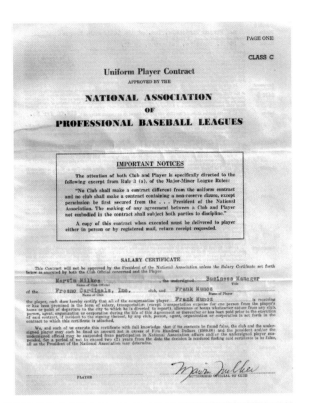

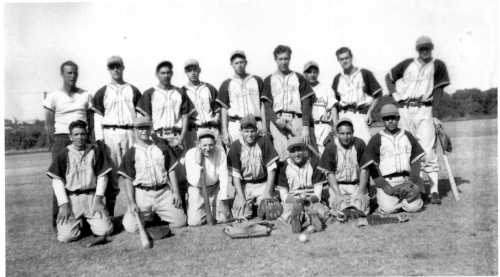

In 1942, the Fullerton High School varsity team became the undefeated Sunset League champions. Juniors Frank Muñoz (second row, third from left) and Joe Juárez (first row, far right) were members. Fullerton was expected to play San Diego for the California Interscholastic Federation (CIF) Championship, but the game never materialized because the Fullerton High seniors and their coach, Richard Spaulding, enlisted to fight in World War II. Sixty-six years later, in 2008, the CIF officially recognized Fullerton as the 1942 champs! (Courtesy of Frank Muñoz.)

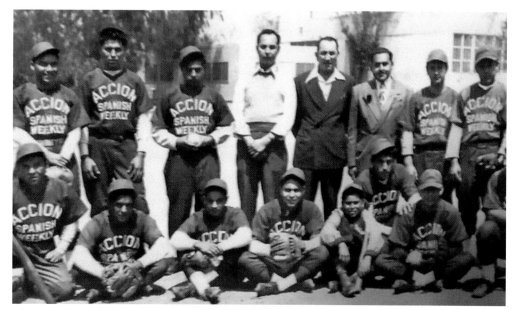

Acción, a Spanish weekly newspaper, sponsored the team pictured here in the Fullerton City League around 1952. Joe Juárez (second row, far right), who played second base, was also a member of the 1942 Fullerton High School California Interscholastic Federation (CIF) Championship team, and his brother Raymond (second row, third from right) was the Acción team coach and the first Mexican American to be hired full-time by the City of Fullerton.

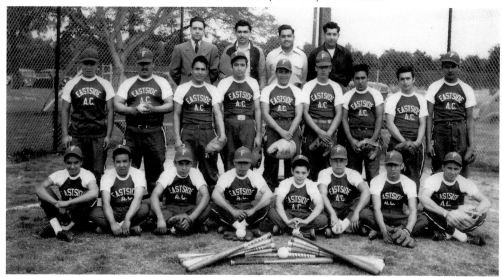

The Eastside Athlete Club (1947–1958) was an outstanding men's fast-pitch softball team that participated in the Fullerton City League. Pictured are, from left to right, (first row) Arthur Rodríguez, Hank Ballard, Joe Juárez, Rudy Pérez, Arthur Suárez (batboy), Eddie Montoya, Frank Muñoz, and Rudy Gómez; (second row) David Hernández, Robert Ruiz, Roger González, unidentified, Phil Hernández, Rudy González, William García, Frank Zúñiga, and Buddy Marmolejo; (third row) Mario Luzar (sponsor), Victor Sandoval (sponsor), coach Raymond Juárez, and Frank Domínguez (sponsor).

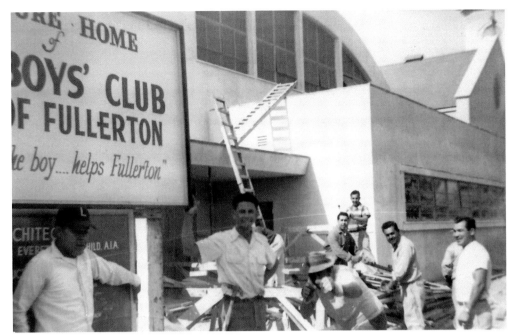

Board members of Eastside Athletic Club are pictured here taking down scaffolding from the new Fullerton Boy's Club in 1952. This volunteer effort was part of the club's commitment to youth athletics, leadership development, and community service typical of Mexican American athletic clubs in the post–World War II era. (Courtesy of Lucy Valenzuela.)

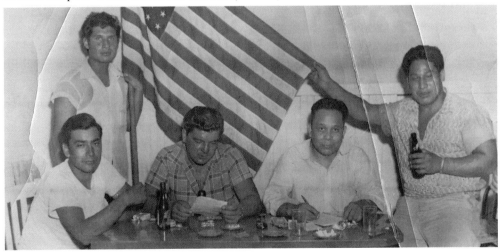

Members of Fullerton's Eastside Athletic Club are shown here socializing after a club meeting about 1950. Baseball presented opportunities for displays of masculinity, which included drinking and partying. These social outlets created a *compadrazgo* (camaraderie) among teammates who faced daily reminders of their marginalized status in society and struggled to change it. The prominently displayed American flag indicates the patriotism of club members, especially since many were World War II veterans, including Elbert Durán (second from right). (Courtesy of Lucy Valenzuela.)

Fullerton native Frank Muñoz, who survived and overcame serious war injuries, is considered one of the greatest ballplayers ever to wear the Fullerton Junior College blue and gold. He is pictured here playing for the Fullerton Junior College Hornets. In addition to his achievements in baseball, he was the 1947 unanimous choice for the All-League Football Helms Athletic Foundation Junior College Player of the Year. In tribute, his jersey, No. 14, was retired for a period of 20 years. (Courtesy of Frank Muñoz.)

Frank Muñoz, pictured on the left, picked cotton and worked at the Fullerton Orange Factory in his youth. After graduating from UCLA and a short stint with the Fresno Cardinals (Class C), Muñoz held various high school teaching and coaching jobs in Southern California. He was the first Mexican American coach hired at Westminster High School (WHS). For 23 years, he was a physical education and Spanish teacher as well as the head baseball coach for the WHS Lions before retiring in 1982. (Courtesy of Frank Muñoz.)

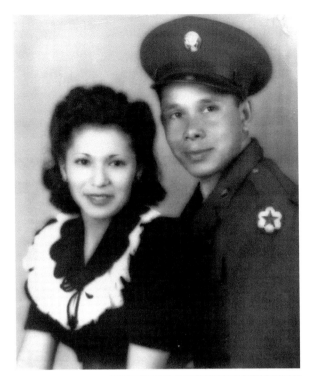

Fullerton resident and World War II veteran Elbert Durán and his wife, Helen, are pictured here around 1945. Elbert enlisted after the attack on Pearl Harbor in 1941 and served in the US Army's 517th Paratroop Combat Team until his discharge in 1946. He fought campaigns in North Africa, Italy, France, and Germany and was wounded when mortar fire hit both his legs in Germany. Elbert, a watch repairman, was a well-known baseball youth coach in the Maple barrio in the late 1950s to 1960s. (Courtesy of Lucy Valenzuela.)

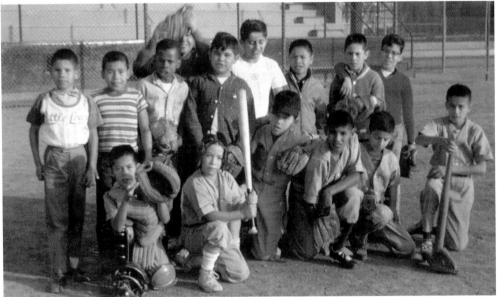

Elbert Durán's sandlot baseball team, comprised of local Maple schoolboys, appears here around 1964. Elbert's love of the sport and commitment to local youth motivated him to sponsor and coach generations of Maple youth. Shown are, from left to right, (first row) Rubén Durán, Miguel Pérez, John Quijano, Joe Hernández, George McClain, and Bobby Valenzuela; (second row) Joe Parra, Roberto Meléndez, Stanley Carmichael, Saúl León (glove on face), Robert Chávez, Albert Rangel, Frank Guerrero, Ernie Arzola, and Albert Turner. (Courtesy of Roberto Meléndez.)

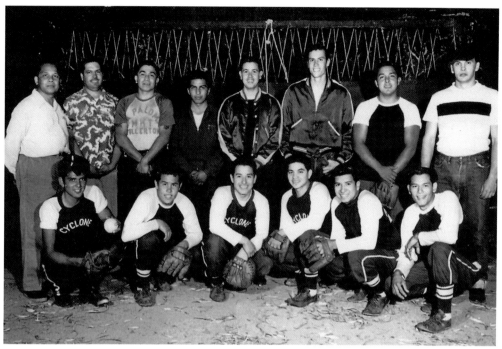

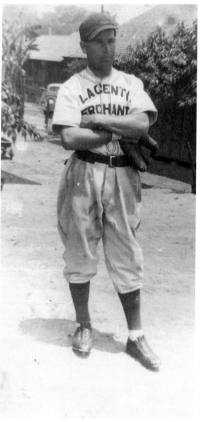

The Fullerton Cyclones were comprised primarily of Fullerton High School students from the Maple barrio who played in the Fullerton City League starting in 1951. La Paloma Market sponsored the team pictured here. Elbert Durán (second row, far left) was the team's coach. Players included Lorenzio Otero, Joe Mora, Joe Sparza, Danny Gómez, Eddie Durán, Ralph Aranda, Dave García, Freddie Arcie, and Benny Lamas. The Eastside Athletic Club and the Cyclones, both Mexican American Fullerton teams, were friendly competitors but not rivals.

Johnnie Guzmán of the Placentia Merchants team is pictured here about 1939 at the La Habra picker's camp El Campo Colorado before a game against the Juvenil Club. Beginning in the 1920s, La Jolla (Placentia), Campo Colorado/Campo Corona (La Habra), Richfield (Atwood), Colonia Independencia (Anaheim), El Modena (Orange), and other barrio groups were part of an informal league of "well-organized and highly-skilled" Mexican teams that played competitively throughout Orange County. Most players were citrus or other agricultural workers. (Courtesy of Monica DeCasas Patterson.)

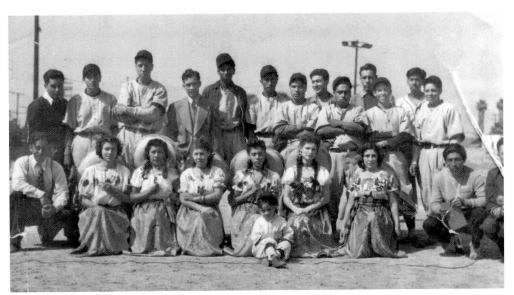

The Placentia Merchants played at White Sox Field in Los Angeles about 1938. The Queens, dressed in folkloric outfits, acted as cheerleaders. Among the players shown here are the following: Frank Rangel, Chris DeSoto, Luis Muñoz, José G. Felipe, Tino Muñoz, Albert Reyes, Fred Aguirre, Paul Saucedo, Alex Aguirre, Morris Estrada, Carlos Felipe, Joe Muro, and Jack Gómez. The Queens are, from left to right, (sitting) Sarah Aguirre, Merci Salcido, Paula Robles, Antonia Robles, Lillian Rod, and Mary Estela Salcido. (Courtesy of Monica DeCasas Patterson.)

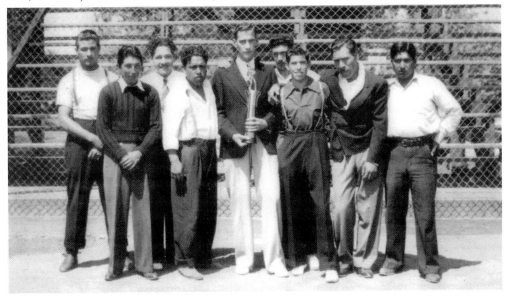

The Placentia Merchants show off their 1939 championship trophy. It was on display at Valencia High School for many years. In the late 1960s, Jack Gómez (first row, far left) and Fred Aguirre (second row, only face showing) became Placentia City Council members, and Jack Gómez went on to become the mayor. Their involvement in Placentia civil rights efforts will forever be remembered. (Courtesy of Monica DeCasas Patterson.)

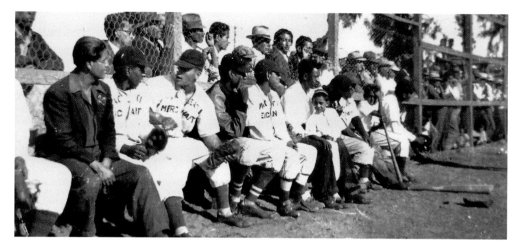

Members of the Placentia Merchants team are pictured here in the dugout during a Merchants versus Mexico Nippon game in Tijuana, Mexico, in 1939. Agent Pete Despartes arranged *binacional* Merchants games. The 100-plus-mile trips to Tijuana were major outings, and teams would pack food and caravan by car. Some of the players pictured here include the following: Armando Castro, José G. Felipe, Tommy Torres, Tom Muñoz, and his son Tom Jr., who accompanied him to most games. (Courtesy of Monica DeCasas Patterson.)

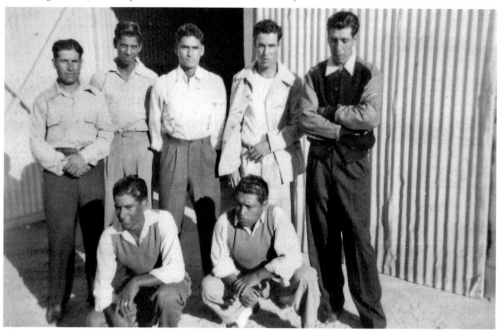

This handsome, well-dressed group of Placentia Merchant players is shown after a game in Tijuana, Mexico, against the Mexican Nippons in 1939. Mr. Soo, of Japanese ancestry, owned and managed the field and the Nippon team. During World War II, his land was confiscated, and he was interned in Jalisco because of his Japanese background. Pictured are, from left to right, (first row) Armando Castro and Paul Saucedo; (second row) John Guzmán, José G. Felipe, unidentified, Sal Cordova, and Chris DeSoto. (Courtesy of Monica DeCasas Patterson.)

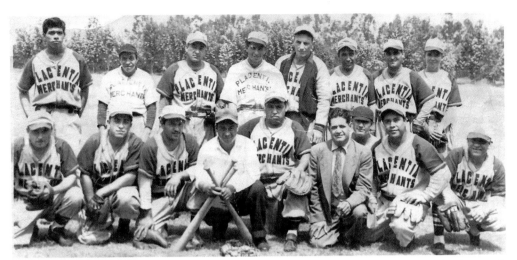

The Placentia Merchants players, shown here about 1943 with orange groves in the background, lived in the heart of the county's citrus district. Most players worked for the Placentia Orange Growers Association, where team manager Tom Muñoz (with bats in the first row) was a supervisor. Many of the era's informal leagues included merchant teams sponsored by local neighborhood businesses (usually more than one). Teams raised additional funds for equipment, uniforms, and supplies by selling tamales and drinks at Sunday games. (Courtesy of Danny Gómez.)

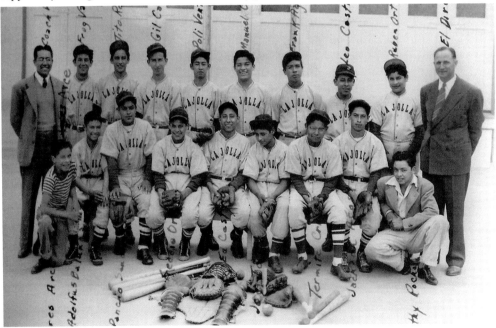

Members of the La Jolla Junior High Red Devils are pictured here in 1944. La Jolla Junior High served the La Jolla, Richfield, and Atwood neighborhoods, and the players were the children of citrus workers, some of whom played baseball during the 1920s and 1930s. Early exposure to the game, natural talent, and excellent coaching by Gualberto J. Valadez helped secure the development of the next generation of outstanding La Jolla ballplayers. (Courtesy of the Gualberto J. Valadez family.)

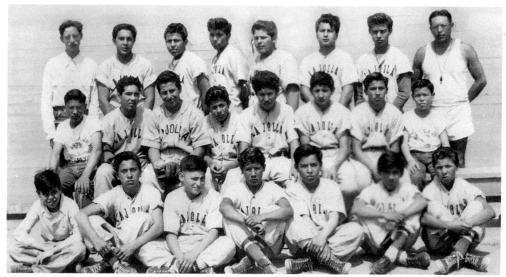

Gualberto J. Valadez started teaching at La Jolla Elementary and Junior High School in 1939. He inspired his students to be proud of their Mexican American heritage, Spanish language, and culture, both in and out of the classroom. He is fondly remembered for founding after-school sports programs for both boys and girls as well as providing adult education classes for their parents. Coach Valadez would blow his whistle and yell out, "OK, you guys, batter up!" (Courtesy of the Gualberto J. Valadez family.)

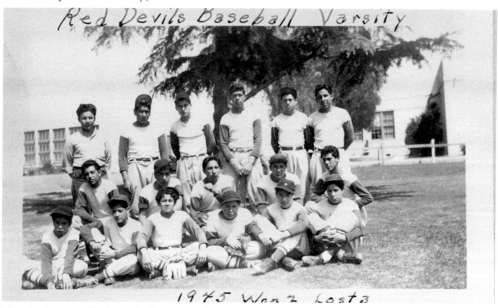

The 1945 varsity Red Devils from La Jolla barrio in Placentia are pictured at La Jolla Elementary and Junior High School. The Red Devils played schools in Anaheim, Orange, and Santa Ana. For over 34 years, Coach Valadez taught self-discipline, positive self-esteem, a strong work ethic, and achievement of one's goals. These lessons helped many of his students succeed and flourish in their adult lives. (Courtesy of the Gualberto J. Valadez family.)

From left to right, starter Valencia High School (Placentia) varsity baseball players Leo and Edward Castro were members of the 1947 Orange League Championship team. This was the first year in the school's history that Valencia won the league title. Leo played third base, and Edward was the catcher. The Castro brothers (identical twins) and Frank Sandoval were the only Mexican Americans who played varsity ball. (Courtesy of Leo Castro.)

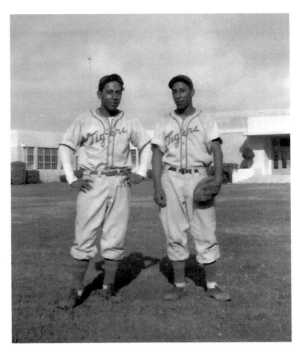

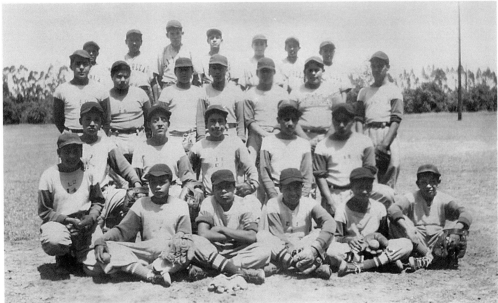

The La Jolla Junior High varsity baseball team of Placentia was undefeated in 1948. The strong baseball teams coming out of the La Jolla barrio were credited to coach Gualberto J. Valadez. Valadez, an educational pioneer who promoted bilingual education and equal rights, made sure that the three-to-four-hour after-school practice sessions would not only help develop athletic potential, but would also provide a source of entertainment. Jim Segovia remembers that he dressed very professionally and befriended team members and parents alike. (Courtesy of the Gualberto J. Valadez family.)

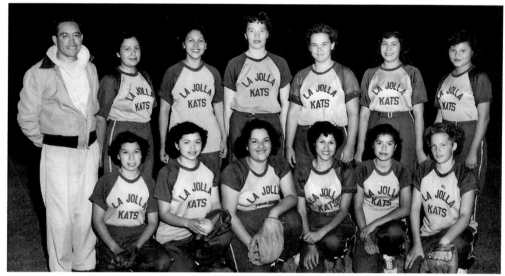

Gualberto J. Valadez formed the La Jolla Kats of Placentia, pictured here, in the mid-1940s. The field lights, which Valadez helped secure, made the sport a local attraction during summer evenings. One night a week was reserved for the girls' games. This North Orange County team unified the Atwood, Richfield, and La Jolla neighborhoods. A few Anglo girls played, including, Lavine Hester (second row, third from left) and Betty Collier (second row, fourth from left).

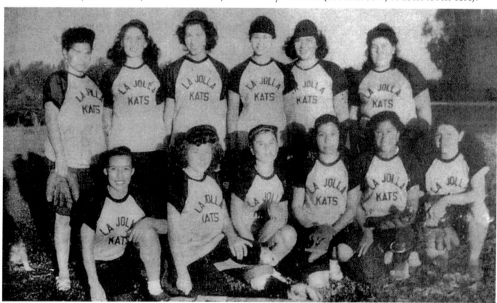

While Mexican American girls' baseball teams had been formed across California and in other states by the 1940s, they still were a novelty in Orange County. These young women broke gender and ethnic stereotypes and had a ball doing it! Pictured are, from left to right, (first row) Mary Helen Castro, Lorraine Ramírez, Seferina Álvarez, Lupe Castro (cocaptain), Elida Solórzano, and Amparo Castro; (second row) Minnie Silva, Anita Velásquez, Marcela Venégas, Margie Salgado, Ofelia Rodarte (cocaptain), and Elisa Segovia. (Courtesy of Lorraine Ramírez.)

Jim Segovia is pictured here with his 1951 Outstanding Athlete trophy from La Jolla Junior High. He was a top-notch pitcher for Valencia High School (La Jolla), Mount San Antonio College, Chapman University, and Bob's softball team. He followed in the footsteps of his mentor, Gualberto J. Valadez, and was a middle and high school educator for 37 years. Jim was the first teacher in Orange County to develop a class on Mexican American history at El Modena High School. (Courtesy of Jim Segovia.)

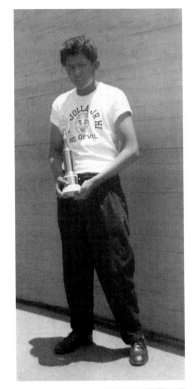

Ron Raya (catcher), Tom Muñoz Jr. (batting), and Jim Segovia on deck (background) played four years of varsity baseball at Valencia High School (Placentia) in the Orange League. The La Jolla Junior High School alumnus racked up numerous high school titles, including Ron Raya as All-League, All-California Interscholastic Federation (CIF) in 1956; Tom Muñoz Jr. as All-League, All-CIF in 1953–1956; and Jim Segovia as All-League in 1956. All three played with the Placentia Merchants on Sundays. (Courtesy of Jim Segovia.)

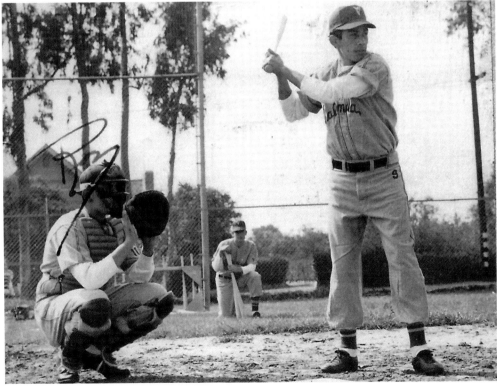

La Jolla Recreation Summer Midget Softball team is pictured around 1950 with baseball equipment. This was one of the various youth teams led by Gualberto J. Valadez and sponsored by the Placentia Recreation Department. Shown are, from left to right, (first row) Alex Ortiz and three unidentified boys; (second row) Blas Solórzano, Ron Eredia, Jackie Pérez, Julio Aguirre, and Bobby García; (third row) David Rocha, Abel Cisneros, Bobby Pérez, unidentified, Raúl Aguirre, and Louis Pineda. (Courtesy of Gualberto Valadez family.)

The undefeated Placentia Pee-Wees team was composed of boys from La Jolla barrio. It was one of the many community youth teams coached by Gualberto J. Valadez. The Pee-Wees defeated the Bradford Blues 18-1 to become the 1959 Pee-Wee League champs. Members included, from left to right, (first row) Mateo Pineda; (second row) Tony Álverez, Marty Steigner, Larry Orosco, and Pablo Sánchez; (third row) Rueben Pineda, Victor Segovia, Jesse Álvarez, Tony Guerrero, and coach Gualberto J. Valadez. (Courtesy of Gualberto Valadez family.)

HOME RUNS FOR THE COMMUNITY

During the 1930s, although some Mexicanos lived amongst the Americanos, many were housed in segregated barrios and colonias. The Mexicano community always came together to share history, culture, language, and traditions, and baseball allowed Mexican Americans to affirm their presence in Orange County. After a full day of learning at school or a hard day of work in the groves, ballplayers reenergized their communities through lively, hard-fought games. Local teams, sponsored by business, *mutualista*, and church groups, brought *unidad y alegría* into their neighborhoods.

Communities, such as La Colonia Independencia, Wintersburg, Colonia 17th, La Fábrica, Westminster, Cypress Barrio, Santa Anita, Logan, and El Modena, reflected a diverse group of people with a common cultural heritage. Some local team members were the United States–born descendants of the old Californio families or of those who had arrived as part of the "great wave" of Mexican immigration in the early 1900s. Others were newer immigrants or came to work as braceros in the United States. All found a chance to play.

Recreational activities brought the community together, and béisbol was one of the most exciting of these events. Teams like the Anaheim Merchants, the Orange Tomboys, the Huntington Beach Tigers, Los Padres de Orange, the Westminster LULAC team, the Road Kings from Colonia 17th, and the Orange Lionettes united families on weekends and late evenings. Some players were first exposed to ball games as young girls and boys observing elders play in local vacant lots. Others had been initiated to sports as part of their school program, perhaps in junior high or high school. Some team members played for a year or two, while others became professional players.

The *peloteros* developed camaraderie and competition—whether as a player on the local barrio team or as a member of the military forces. Baseball enabled the players to increase their self-esteem, develop leadership skills, and serve as role models for others. As they confronted and challenged both cultural and gender expectations of the day, women baseball players proved that they were just as qualified and competitive as the men. This book salutes each and every man and woman player of the past and of the present. *Que viva el béisbol, y los beisbolistas!*

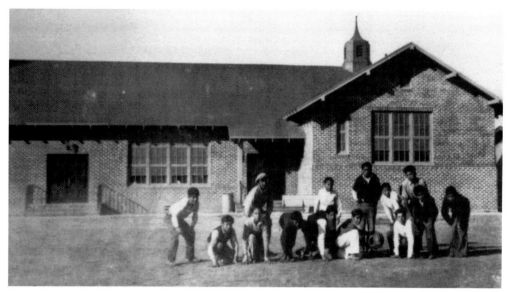

Pictured above, several children appear ready for sports outside Anaheim's La Palma Mexican School in the 1920s. Below is the school softball team around 1946 with Alex Jiménez, possibly the first Mexican coach in Anaheim, who also taught in the Anaheim School District for almost 40 years. The PTA and the League of United Latin American Citizens honored him for his contributions to students. The boys in these pictures represent two barrios, La Conga and La Fábrica. The photograph below includes Saturnino Muro and Arturo Guerrero, children from longtime Anaheim families. (Courtesy of Anaheim Public Library.)

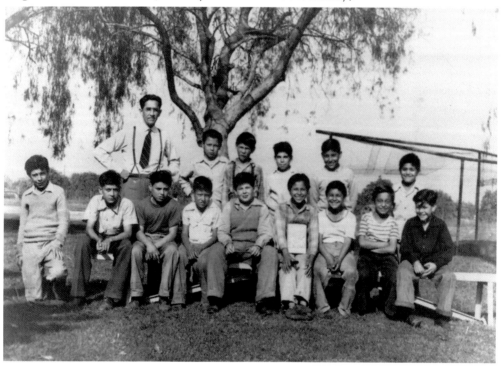

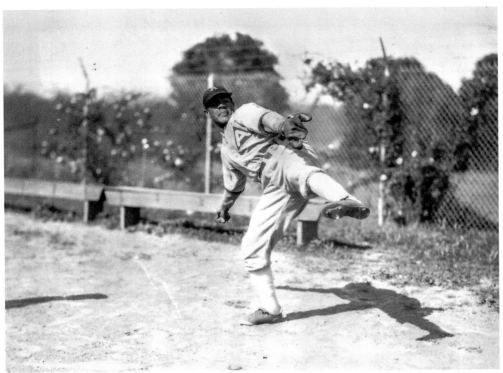

Both photographs showcase Ray Ortez, a star baseball and softball pitcher for Anaheim High School from 1934 through 1937 under the direction of Coach Glover. Ortez was victorious in the Orange and Sunset Leagues, hurling for league championship titles for Dick Glover's Nine. After high school, he played softball and had a 10-year career playing for teams in Arizona, Utah, and Central and Southern California. Ray Ortez hurled the Phoenix Lettuce Kings into victory in the championship series to capture the 1938 National Softball Championship title. (Both, courtesy of Monica Ortez.)

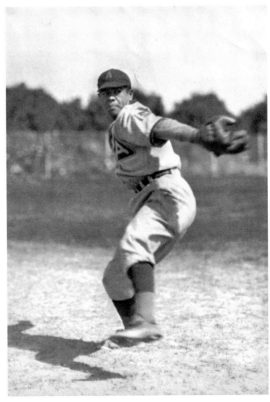

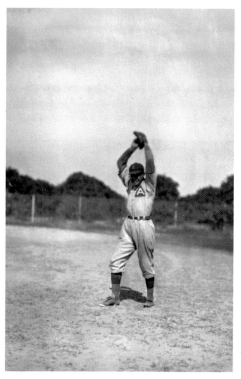

In the 1930s, Ray Ortez also played baseball under the direction of his father, Ray G. Ortez, manager of the Anaheim Merchants baseball team (pictured in both photographs). The Merchants consisted of then present and former Anaheim High School baseball stars and promising collegians. The Merchants played in the Los Nietos Valley Manager's Association Leagues against Stanton, Placentia, Pico, Sunshine Acres, Wilshire Oil Company, and Rivera teams. Home games were played at Anaheim High, and the first game of the 1938 season was postponed due to the great Santa Ana flood. (Both, courtesy of Monica Ortez.)

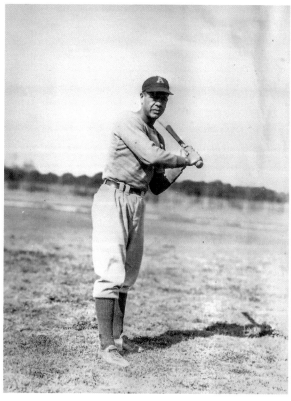

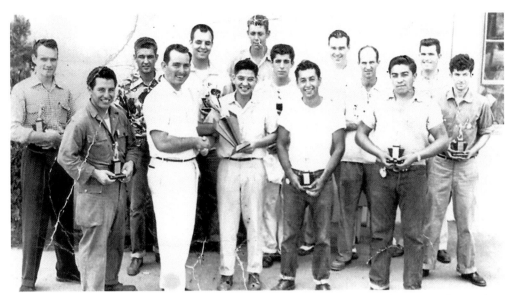

Like other companies, Kwikset Corporation sponsored a softball team, known as the Kwikset Hornets. Players in this late-1950s photograph include Danny Gómez (first row, far left) and Danny DeLeón (first row, far right). Kwikset belonged to the Anaheim Industrial League. Team members played at Pearson Park and La Palma Park against teams such as the Dixie Cups and Anaheim Optimists. Over the years, both men and women, including Raúl Mendoza, Lorie Peralta, and Joe Hernández, played for Kwikset. (Courtesy of Danny Gómez.)

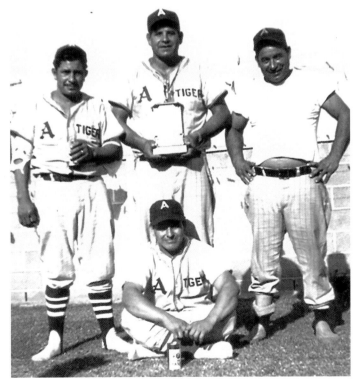

The Gómez brothers first played for the Placentia Merchants and then joined the Anaheim Tigers for about three years in the 1960s. After serving in the military, they typically played ball at Boysen Park in Anaheim. Pictured are, from left to right, (first row) Danny Gómez; (second row) Danny's brothers Rudy, Manuel, and Frank. Danny recalls how special Sundays were; the families provided their support at the games and then gathered at different homes to socialize. (Courtesy of Jim Segovia.)

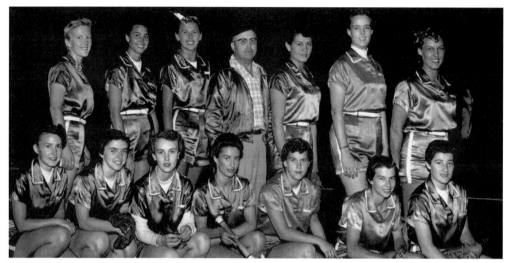

One of the county's most famous softball stars around 1950 was Annie Cruz (second row, fifth from left). Annie began to play baseball in sixth grade and, as a sophomore at Orange High, signed on with the Orange Lionettes. Annie's pitching skills were recognized by all. Newspapers often referred to her as a "pitching sensation" and as a "fireball artist." Numerous softball teams sought Annie out. She and fellow players served as important role models for others. (Courtesy of Jim Segovia.)

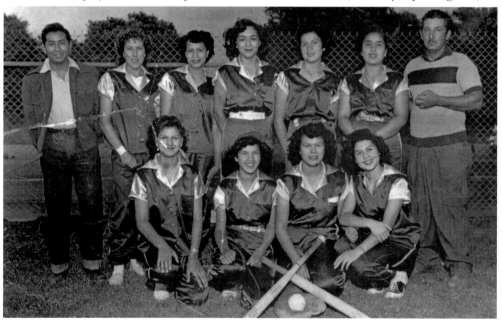

Women proved that they were just as athletic and victorious as the men. The Fullerton-Anaheim McMahan girls included Annie Cruz in the 1950s, one of the best pitchers in Southern California. Annie also played for the Buena Park Lynx and Fullerton Sweethearts. She pitched against some of the top teams. Pictured are, from left to right, (first row) unidentified, Gloria DeLeón, Virginia Cruz, and unidentified; (second row) coach Frank Cruz; Madge ?; Eleana Cruz; unidentified; Annie Cruz; Annie Cárdenas; and manager Tony Cárdenas. (Courtesy of Jim Segovia.)

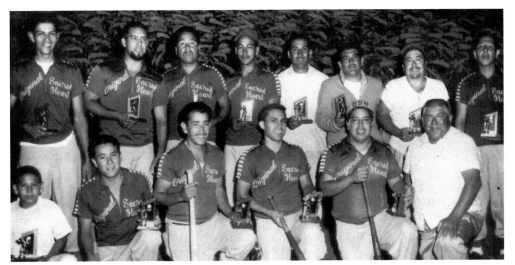

Churches such as Sacred Heart Mission of Anaheim's Colonia Independencia, also sponsored baseball teams. This 1960s photograph includes Lupe Gonzales (first row, fourth from left), Ramón Savala (first row, sixth from left), and Eddie Ramírez (second row, first player). Savala was born and still lives in the old barrio of La Fábrica; when he was young, he attended Anaheim's Mexican school. He also played for the Eastside (Beer) Company. Today, Savala experiences great pain in his fingers from having served as a catcher for so many years. (Courtesy of Adeline Gonzales.)

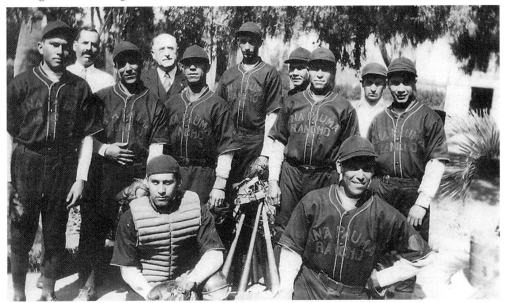

Working in the fields or in the orchards sometimes led to the formation of baseball teams. Ranch owners might encourage their development to gain worker loyalty. In the 1930s, catcher Joe Maldonado (first row, left) and pitcher Alcott Encinas (first row, right) shared great rapport playing for the Anapauma Ranch team, a ranch located in El Modena. An Orange High School teacher coached the team. The umpire was L. Contreras, and the manager was T. Martínez. (Courtesy of Matt A. Encinas.)

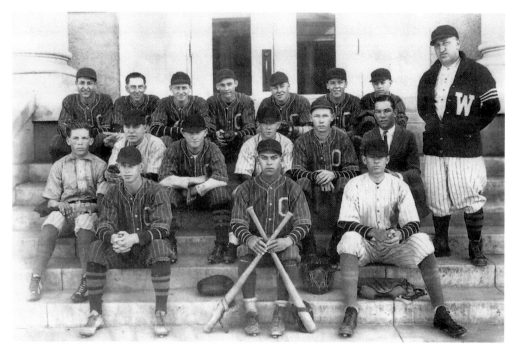

Alcott Encinas illustrates how Mexican Americans were active in baseball as early as 1924. Encinas is pictured with his teammates from Orange High School; at the time, he was living in El Modena. Encinas was considered one of the best pitchers in the league. Their biggest rivals at the time were Anaheim and Santa Ana High Schools. All were proud of the uniforms donated to the school and especially appreciated their high school coach's dedication. Encinas was proud of his Juaneño Indian heritage. (Courtesy of Matt A. Encinas.)

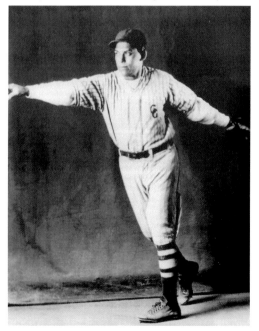

Encinas, the ninth of 12 children, was so small as a baby, he fit inside a shoe box; however, years later, he became known as "Big Al." He excelled in baseball, boxing, and gymnastics. The family would travel in their jalopy to distant games. From 1920 to 1933, Encinas was a sought-after semiprofessional baseball pitcher, who could also speak English, Spanish, German, and Basque. To any potential athlete, he was a mentor. For those who did not play, he taught them to appreciate the game. (Courtesy of Matt A. Encinas.)

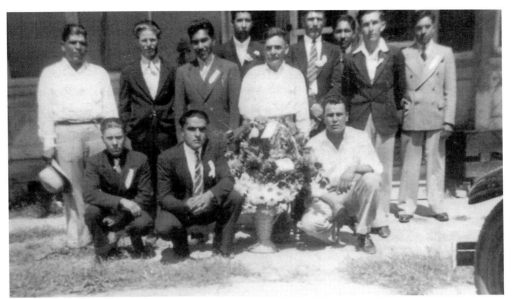

This 1941 prewar photograph reveals a Los Alamitos softball team sponsored by the Dr. Ross Dog Food Company. All the players were from Mexico, many from Jalisco. Several would eventually serve the United States in World War II. Here, team members are presenting flowers to the company in appreciation for its sponsorship. The manager and organizer of the team was Epifanio Nápoles. León Vásquez was first baseman and outfielder for the team. (Courtesy of John Teutimez.)

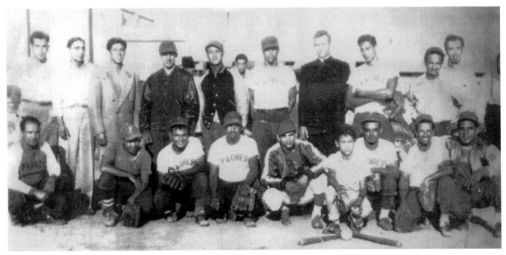

The 1946 Padres baseball team of Cypress Street Barrio provided excitement in Orange. Players included, from left to right, (first row) Mike Cruz, unidentified, Pete Montoya, Jack DeLeón, Henry Martínez, Paul Guzmán, Reggie Martínez, Manuel Salcido, and Félix Orozco; (second row) Frank Enríquez, Vidal Chávez, Chilo Beltrán, Cirilio Gómez, Augustín Camarena, Salvador Félix, Father Collins, Salvador ?, Albert Salcido, and Rosano Alonzo; (third row, in extreme back) Doroteo DeLeón and Robert Figueroa. (Courtesy of the Local History Collection, Orange Public Library, Orange, California.)

MEXICAN AMERICAN BASEBALL IN ORANGE COUNTY

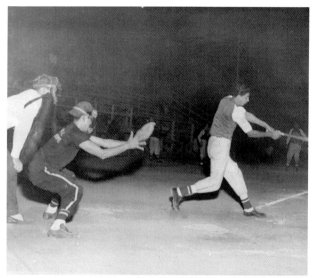

Los Padres played all around Orange County. Money gathered from general collections and concession stands helped purchase equipment. Neighborhood residents often worked in citrus-related activities. Baseball provided a vehicle for young and old to socialize together. Featured in this action-packed 1948 photograph is batter Salvador Félix. (Courtesy of the Local History Collection, Orange Public Library, Orange, California.)

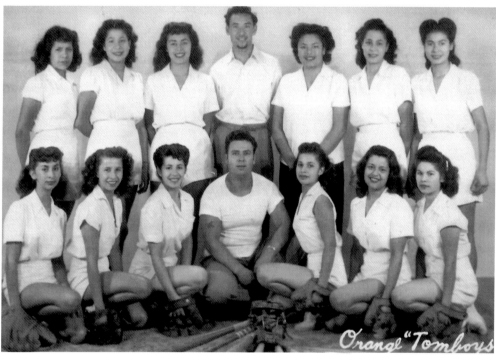

The Orange Tomboys from Cypress Street Barrio played against other Mexican all-girls' teams from Placentia, Anaheim, Santa Ana, Westminster, and La Habra. Pictured are, from left to right, (first row) Becky Martínez, Katie Escoto, Mary Escoto, Elías Guzmán, Helen Escoto, Terry Alonso, and Caroline García; (second row) Angela Adame, Lucy Cornejo Durón, Carmen Cornejo Gallegos, Ralph Cornejo, Lupe Cornejo, Emma Cornejo Félix, and Delia Cornejo. They were regional women's team champions in 1947. Elías Guzmán served as head coach, and Ralph Cornejo was the team's assistant coach. (Courtesy of the Local History Collection, Orange Public Library, Orange, California.)

The Cornejo sisters began playing in an empty lot near railroad tracks and were gradually joined by other girls. As members of the Tomboys, they played 26 games in Orange County and won every one of them, leading to their 1947 championship. "Nobody liked us because we beat everybody; we were rivals to everybody," comments Lucy Cornejo. Lucy believed that their victories helped lessen the prejudice felt against Mexicans. Besides ball, other Sunday activities included going to Corona Del Mar Beach. Pictured here are, from left to right, (sitting) Carmen Cornejo Gallegos, Violet ?, Lucy Cornejo Duron, and Lupe Cornejo; (standing) Liz Vasquez, Emma Cornejo Felix, and Delia Cornejo Cross. The girls eventually moved on to boyfriends and husbands. Ballplayers of the past no doubt continue to serve as role models for others today. (Courtesy of the Duron family.)

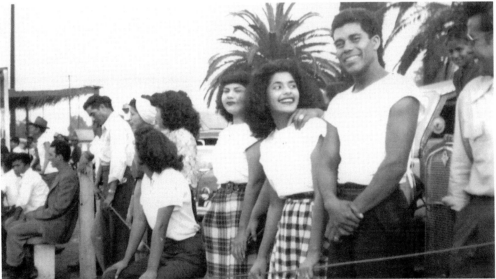

This 1945 photograph of a baseball game audience captures the fun and excitement of the afternoon. Delicious food and colorful decorations added to the atmosphere. Featured are Lupe San Román and friends; the San Román family lived on Cypress Street in Orange. The games helped reinforce cultural and community bonds, but for the youth, they also provided an opportunity to meet one's future boyfriend or girlfriend. (Courtesy of the Local History Collection, Orange Public Library, Orange, California.)

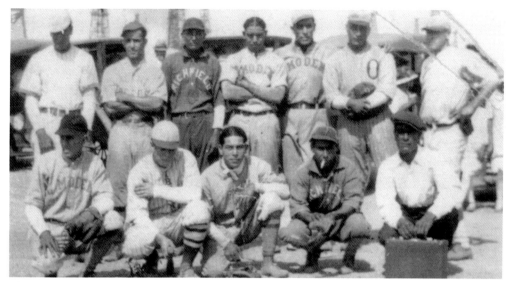

Players from El Modena and the Atlantic Richfield teams appear in this 1915 photograph. Ball games also provided an opportunity to get rid of stress from working all week at the orchard, the factory, or in the fields. (Note the oil derricks visible in the background.) Viviano Bracamontes (second row, far left) is pictured among the players. (Courtesy of the Local History Collection, Orange Public Library, Orange, California.)

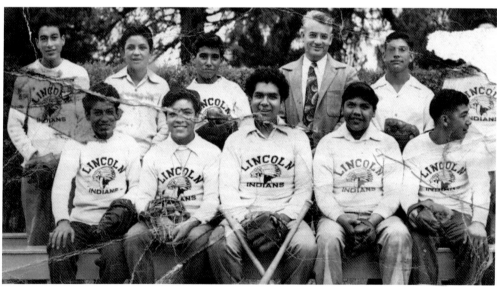

Baseball helped reinforce American identity. Young boys, such as these at Lincoln Elementary School in El Modena, enjoyed being part of a team; however, they probably did not understand why they were separated from Anglo peers. This photograph was taken in 1946, a few years before local schools became desegregated. Students include Tony Becerra, Freddy Martínez, Rudy Hernández, Simón Robles, Steve Nieblas Sr., and Chelo Ledesma. (Courtesy of the Local History Collection, Orange Public Library, Orange, California.)

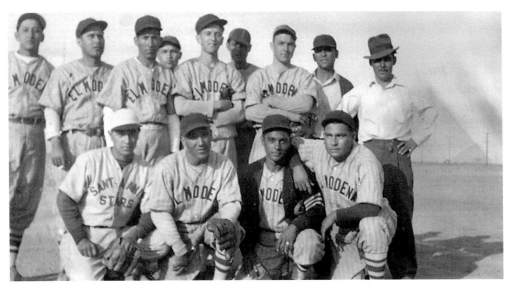

The Maldonado family, Joe, father, and sons Aaron and David, all played for the Placentia Merchants, as did Aaron and David's cousin Peter Maldonado. They used to play in Corona, Los Angeles, and Tijuana. This 1930s El Modena team photograph includes Joe Maldonado (second row, second from left), a catcher at only five feet, four inches tall but with lots of power as a hitter. David recalls that the Boston Red Sox scouted his father, but during that time, he would have had to pay his own way East, and his family could not afford the cost. (Courtesy of David Maldonado.)

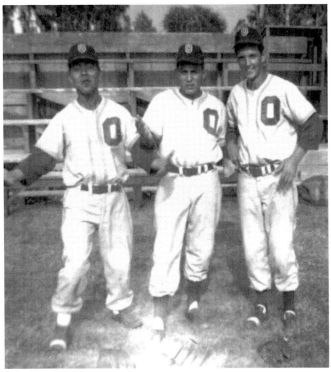

From left to right are cousins David Maldonado and Peter Maldonado as well as their good friend Harvey Moreno. Harvey's family is well known for its businesses, Moreno's Restaurant in Orange and a little *tiendita* called La Morenita. All three players attended Orange High School in 1955. David Maldonado's brother Aaron, along with Ted Herrera, once played for Orange Coast College in Costa Mesa. Ted would pitch, and Aaron would catch. At that time, their team won the community college state championship. (Courtesy of David Maldonado.)

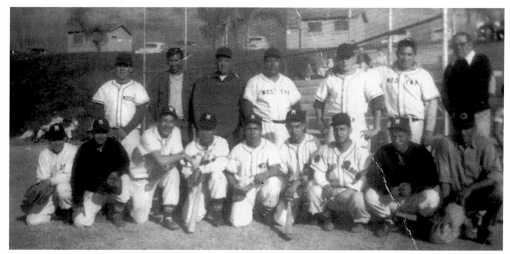

Sundays at La Paloma or El Modena Park were for ball games and family. While the bare hills surrounding the field are now full of houses, the diamond is still home to all levels of baseball, including El Modena High School. This 1955 team includes, from left to right, (first row) unidentified, Blas Marrón (business manager), Steve Nieblas Jr., two unidentified players, Dave Maldonado, Joe Maldonado, Eddie Cisneros, and José G. Felipe (coach); (second row) Aaron Maldonado, Carlos Felipe (manager), Fred Domínguez (umpire), Nick García, Peter Maldonado, Frank Gómez; and Francis McNeil (sponsor). (Courtesy of Monica DeCasas Patterson.)

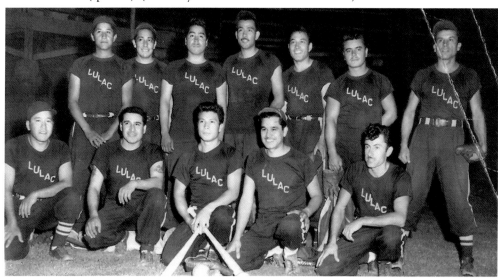

LULAC of Santa Ana sponsored this team in which Julio Méndez (second row, fourth from left) served as a pitcher. Julio was a nephew of Gonzalo Méndez, a member of one of the families involved in the historic *Méndez v. Westminster* desegregation case. This photograph, taken around 1947, includes, from left to right, (first row) Socorro Rivera, Jimmy Romero, Johnny Pérez, Tony Rivera, and Tony Nieblas; (second row) Ramón Rivera, Joe Rivera, Pete Guadán, Julio Méndez, Ted Alarcón, José Zepeda, and Henry Avalos. Illustrating how baseball was often a family affair, the Riveras were all cousins. (Courtesy of Bea Dever.)

Sigler Park was the home field for the Barber City Café team and Los Toreros. The Penhall family donated three acres of land for the construction of a diamond, which came to be known as Penhall Field. Around 1930, a local grocer went to court over an admission charge; eventually, it was declared illegal, and spectators were no longer charged the fee. This late-1940s photograph includes, from left to right, (first row) Ray Vega; (second row) Diego Gonzales, George Cepeda, Jimmy Romero, and Tony Rivera; (third row) Katie Vela, Sally Pérez, Lydia Gonzales, and Connie Gonzales. (Courtesy of Albert Vela.)

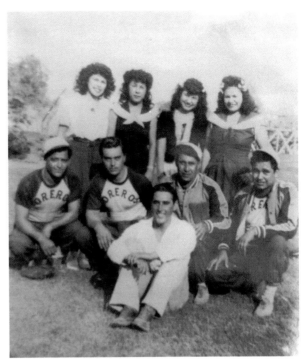

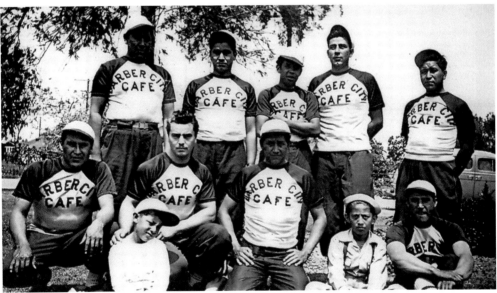

The Barber City Café team members from Westminster in this 1948 photograph included World War II veterans and barrio residents. Team members sometimes played as Los Toreros or as Los Veteranos. Pictured are, from left to right, (first row) George Cepeda (batboy), Henry Rivera (batboy), and Rosendo Vega; (second row) Jimmy Romero, George Cepeda, and Ramón Rivera; (third row) Joe Rivera, Tony Rivera, Nacho Medina, Julio Méndez, and Socorro Rivera. The Barber City Café team played local teams as well as teams from Mexico. Five Rivera cousins were members of this group. (Courtesy of Bea Dever.)

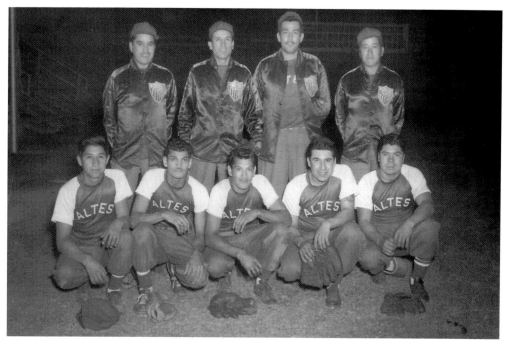

As demonstrated in this 1948 photograph with members wearing Altes shirts and LULAC jackets, Westminster ballplayers circulated among different teams. Altes, a brewery company from Detroit, produced a golden lager beer and acquired the Aztec Brewery Company, located in San Diego, in 1938. Altes team members are, from left to right, (first row) Ramón Rivera, Arnold Murillo, Joe Murillo, Jimmy Romero, and an unidentified player. LULAC players are, from left to right, (second row) Tony Rivera, Henry Luévanos, Julio Méndez, and Socorro Rivera. (Courtesy of Bea Dever.)

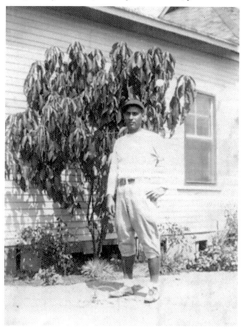

Around 1930, Joe Maldonado was photographed at his home in El Modena. He played for the Placentia Merchants and raised his sons and family members to love baseball, including cousin Pete Maldonado. At the time, the manager of the Merchants was Tommy Munoz, one of Orange County's most notable managers. David Maldonado, Joe's son, got to play with the Dixie Cup Industry League, fast pitch softball for 15 years. Mothers and fathers watched with pride as their little ones grew up to become well-known players in Orange County. (Courtesy of David Maldonado.)

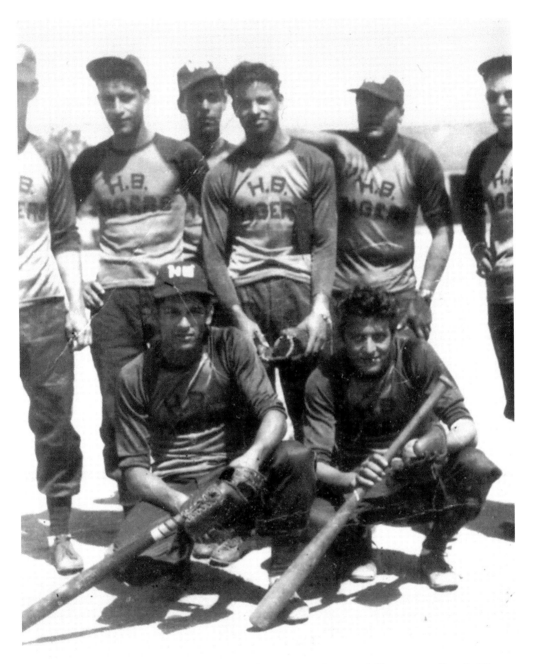

The Huntington Beach Tigers were players from Wintersburg and Huntington Beach. This c. 1947 photograph shows players from both communities, including (first row) Rubén Alvarez and Cándido Beltrán; (second row) Wally Potts, Alfonso Ruiz, Angel Varela, Tim Alvarez, and Vincent Jurado. Some members of the Tigers worked in farm-related factories, and several others worked on a military base in Seal Beach. They played teams from La Colonia Juárez and Santa Ana. Other Mexican communities in western Orange County were Talbert and Smeltzer. (Courtesy of Anita Varela.)

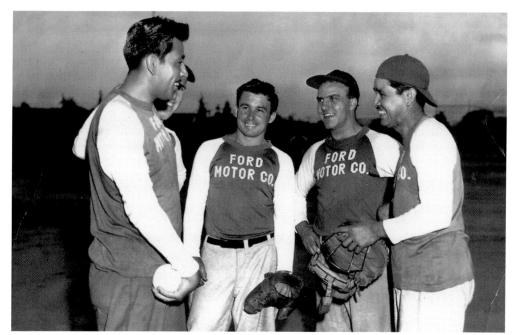

From the 1940s through the 1960s, Los Angeles became the second largest auto-manufacturing region in the nation. By sponsoring baseball teams, the Ford Motor Company supported employees in their extracurricular activities and also advertised in the community. Several players on this Ford team were from Westminster and were employed at the Pico Rivera plant. Team members enjoying moments of camaraderie include Julio Méndez, the pitcher (far left), and Tony Rivera, the catcher (far right). Below, Tony (left) is helping Julio warm up for a game. (Courtesy of Bea Dever.)

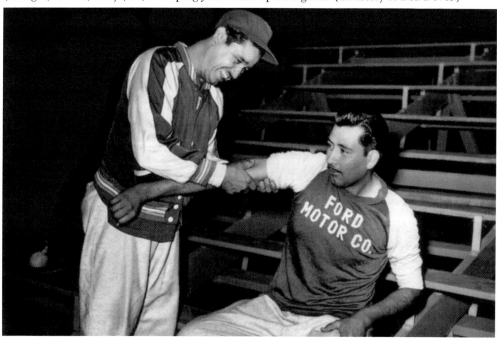

Rudy López (left) and Emilio López (right) appear in this Barrio Santa Anita photograph. Rudy is wearing a Garden Grove High School Argonauts uniform. The image was taken at their grandmother's home around 1940 when Rudy was approximately 18 years old. Rudy also played for Los Toreros de Westminster and once tried out for the Chicago Cubs. When World War II began, Rudy entered the Navy and ended up in Okinawa. Rudy eventually had six daughters and two sons; the girls followed in the footsteps of their father by playing ball. (Courtesy of Rudy López.)

Robert Rivas was one of five brothers that played at Tustin High School in the 1950s. He was an All-Orange League player his senior year of high school and was considered one of the county's best all-around athletes. Bob played football at Santa Ana College where he was named to the US All-America Junior College team. After retiring from a career in law enforcement, Bob now enjoys playing golf with the Mexican American Golf Association (MAGA). Bob is still a fierce competitor. (Courtesy of Jim Segovia.)

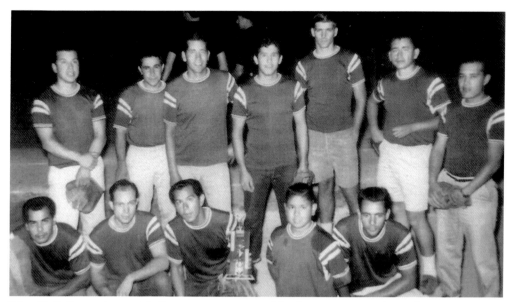

This 1962 Santa Ana softball team was sponsored by Rivas Tamalería/Tortillería, located on Fourth Street in Barrio Artesia, in Santa Ana. Pictured in the second row is Jesse Ruiz (center). Other players include Don Abbott, Micky Sullivan, Pascual Rivas Jr., and Tony Rivas. (Courtesy of Jesse Ruiz.)

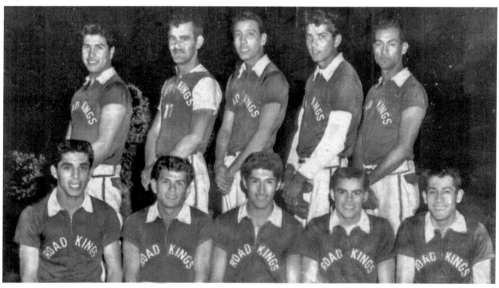

The Road Kings from Colonia 17th (Santa Ana and Garden Grove) evolved over the years. Several signed up for the Marine Reserve and were eventually called into the Korean War; some even played ball in Japan and Korea. When they returned, they resurrected the old baseball team. This 1952 photograph shows, from left to right, (first row) Ray Cázares (team captain), Lupe Yñiguez, Mony Tovar, Ralph Ochoa, and Richard Méndez; (second row) Monnie Almazán, ? Trujillo, Sammy Cañas, Vincent Silva, and Tony Borrego. In 1954–1955, the Road Kings were Orange County Softball Champions. (Courtesy of Richard Méndez.)

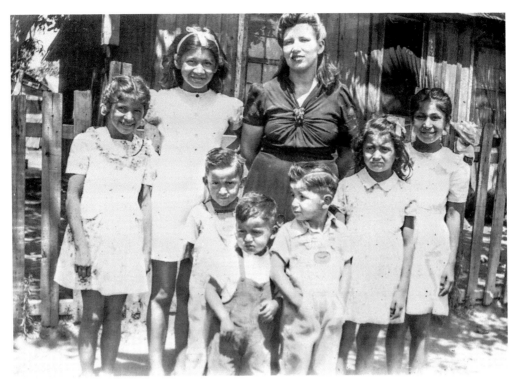

Shown at far left in this 1940s photograph, Carmen Luna from Santa Ana began playing baseball at Logan School and, at one time, was the only girl playing on an otherwise all-boys' team. She eventually formed part of the Flames women's team from Santa Anita. Carmen was allowed to play ball as long as the tortillas were made by the time she stepped out the door. She never wore a pair of shorts until she began to play baseball. (Courtesy of Carmen Luna.)

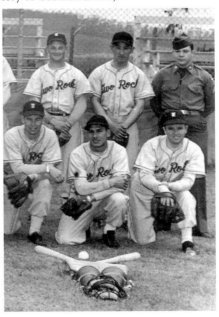

David Paul Camacho (first row, center) appears in this 1951 Two Rock military baseball team photograph from the Petaluma, California, Army base. David lived in a foster home for several years and began to play baseball when he was about 16 years old, after having picked cotton and citrus as a young boy. Since he spoke several languages, including Russian, he served as a translator in the Army Secret Service Program. David Paul returned to Santa Ana and umpired for local teams. He was considered a hero because of his personal success. (Courtesy of Mary Camacho.)

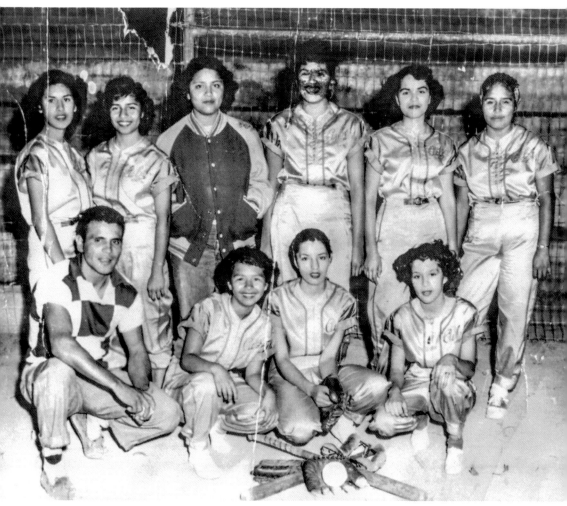

This photograph shows the 1949–1950 Santa Ana Cubs, a team from Logan Barrio. Sallie Parga (first row, in front of equipment) is proud that the *Santa Ana Register* newspaper once featured her team. Their uniform consisted of blouses and long pants. According to Sallie, the Santa Ana Cubs team members were always excited because "they always won." The girls loved to show off playing since it was one way to attract the boys' attention. (Courtesy of Carmen Luna.)

THE GOLDEN STATE

Mexican American baseball has a rich history in California. Baseball, and later softball, has been played in every major geographical region, including the San Diego area, the Inland Empire, the Pomona Valley, Orange County, Greater Los Angeles, the San Fernando Valley, the beach and desert communities, the Central Coast, the Central Valley, the Bay Area, and Northern California. Mexican Americans played all types of baseball and softball, including youth, high school, and college; on community-, church-, and business-sponsored teams; on men's and women's teams; semiprofessional and professional; military; and on Mexico-based teams.

Each community had its fair share of powerhouse teams and great baseball heroes who have become legends still fondly remembered. There were always one or two extraordinary men who led by example in establishing baseball and softball fields; forming teams; and becoming coaches, managers, and umpires. These special men dedicated their entire lives to youth sports, and as a result, some have had little league fields and other sports facilities named in their honor.

When local teams went on the road to play against other teams, their dedicated fans and supportive families followed along, giving them moral support. Baseball networks became family networks that in turn became political networks. Civil rights and veterans' groups, including mutual aid societies, the American GI Forum, the League of United Latin American Citizens, American Legion Posts, and the Veterans of Foreign Wars, sponsored baseball and softball teams. These civil rights groups clearly understood that baseball was a political and cultural vehicle to bring about social change.

The relationship between gender equality and softball is taking its place among this emerging research. Questions regarding the role of softball and its impact on Mexican American women during the Great Depression, during World War II and Korea, and the postwar–Mexican American civil rights movement need further examination. Only when the social and political impact that softball had on the personal, community, and professional lives of Mexican American women is fully comprehended will there be a complete and accurate historical portrayal of baseball and softball in the Mexican American community.

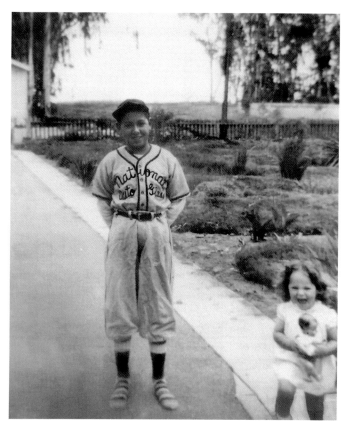

The Los Angeles–based National Auto Glass team batboy is Alonzo Ernesto Orozco, with his sister Elisa Ann Orozco-O'Neil. Alonzo received degrees from UCLA and Pepperdine University. Elisa received a degree from Cal State Northridge. Alonzo's brother Joseph Peter Orozco played ball at the College of the Canyons in Valencia and at Los Angeles Valley College. Alonzo's son Martín played at Moorpark and Mission Colleges. Alonzo's grandchildren Martín Jr. and Stephanie also played ball. (Courtesy of the Orozco Baseball Collection.)

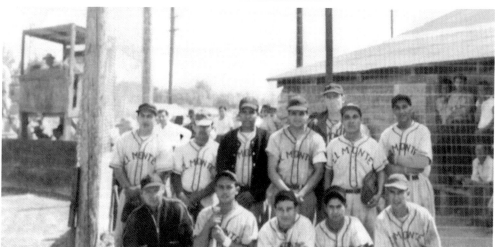

The man wearing the hat in the booth (far left) is Manuel P. Venégas. He played ball with Medina Court and later managed, earning a reputation as a brilliant strategist. He became an umpire but quit due to players fighting. Manuel eventually became a bilingual game announcer and was often referred to as the Mexican "Vin Scully." He is credited with helping integrate baseball games in El Monte by inviting Anglos to attend games. All seven of his boys played ball. (Courtesy of Lucy Vera Pedregón.)

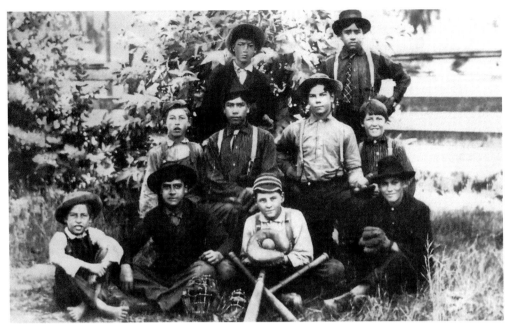

This 1908 Vernon baseball photograph includes Efrén Montijo (third row, far left). Montijo played baseball at Huntington Park High School around 1911. He was the starting pitcher in his freshman year at Occidental College in 1914 and was leaning toward a career in professional baseball when he joined the Army in World War I. He was proficient in French and German and was later captured by the German army. (Courtesy of Charlotte Montijo Sauter.)

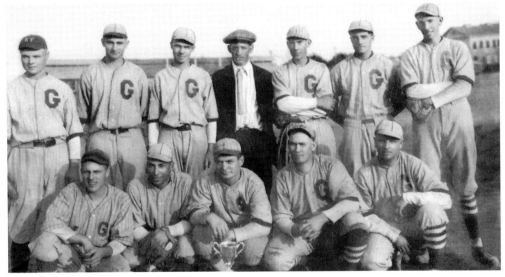

Having been gassed three times on the battlefield, Efrén Montijo (first row, second from left) did not pursue a baseball career. He worked for Goodyear Tire Company and later for Standard Oil as an engineer in Signal Hill and Kern County. He purchased three ranches in Porterville, where he raised five children, but lost much during the crash of 1929. He remained active with the American Legion and the Veterans of Foreign Wars (Courtesy of Charlotte Montijo Sauter.)

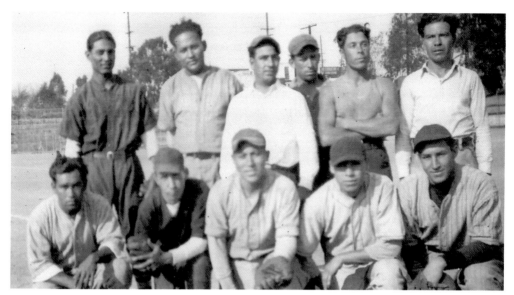

The San Jose baseball team from East Los Angeles was organized around 1927. Due to the lack of funds, they did not have uniforms, and their equipment was secondhand. Guadalupe E. López was the team manager (second row, third from left), and three of his family members, including his cousin Steve Díaz (first row, second from left), brother Jesús (second row, far left), and cousin Vincent Macías (first row, center) played on the team. (Courtesy of Carmen L. Reyes.)

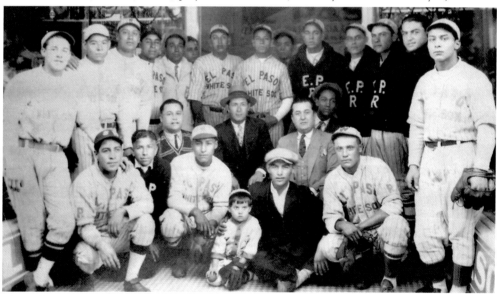

The White Sox team was sponsored by the El Paso Shoe Store and played games at White Sox Park in Los Angeles. During the 1920s and 1930s, the team had several outstanding players, including Tony Gamboa. Gamboa was born in 1911 in Silver City, New Mexico, moving later to the Watts section of Los Angeles, where he played ball at Franklin High School. He later played for the Long Beach Bakery, Downey Wildcats, East Long Beach Merchants, and the Fullerton All-Stars. (Courtesy of Vivienne Ryan.)

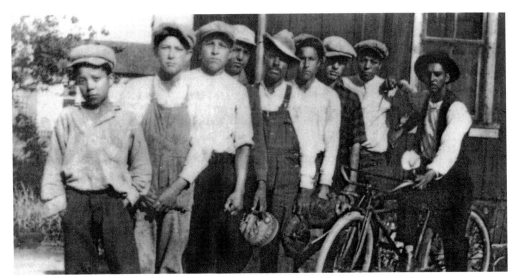

This 1917 photograph depicts an early Los Angeles Mexican American baseball team. Many teams during this era included brothers who played together, and this team had five brothers. Ventura Saiza is on the bike while his brothers Manuel, Fidencio, Martín, and Pepe are directly to his right. Ventura worked as a taxi driver. Many of the brothers had children and grandchildren who also played baseball in Los Angeles for decades. (Courtesy of David Olmos.)

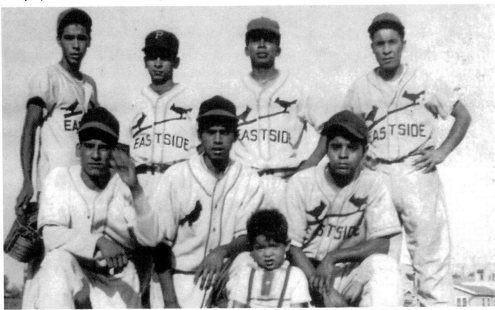

This East Los Angeles team played at Evergreen Park in 1953. Cousins George and Sal Saiza had fathers on the 1917 Los Angeles team shown above. The batboy is five-year-old Alfonso Olmos; he later played in high school and at East Los Angeles College. He was drafted by the San Francisco Giants and the US Army. His brother David recalled that he was proud that Alfonso had come by to see him play in La Puente before being shipped overseas. Alfonso was killed in Vietnam, and David named his son Alfonso in his honor. (Courtesy of David Olmos.)

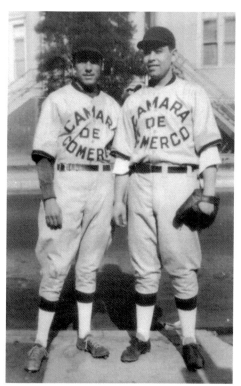

Ray Armenta (right) played for the 1934 La Cámara de Comercio Mexicana (Mexican Chamber of Commerce) team in Los Angeles. Ray was born in 1910 to Pablo and Victoria Oros Armenta. Due to the Mexican Revolution, the family fled to Tucson, Arizona, in 1914. In 1922, the family moved to Los Angeles. It was here that Ray acquired his passion for the game of baseball. He played for the Los Angeles Aces, Mission Hosiery, La Alianza Mexicana, National Auto Glass Company, Carmelita Provision Company, Midland Rubber Corporation, and the Shell Oil team. He played over 40 years. (Courtesy of Bea Armenta Dever.)

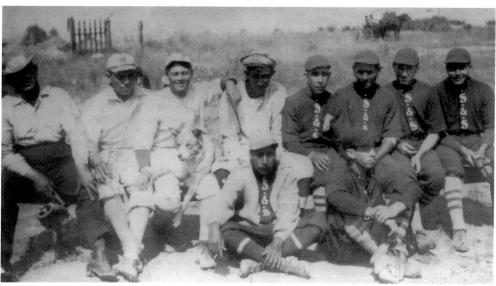

The 1915 S&S San Gabriel team played near the San Gabriel Mission. Mike Salazar is seated at far left. Mike and his wife, Minnie, owned property where they built a baseball diamond. His brother David Salazar (far right on the bench) is the grandfather of Darrell Evans who played in the major leagues between 1969 and 1989. Players are, from left to right, (seated on the ground) Félix Vigare and Mantec (on the bench) Mike Salazar, "Big Joe" Acuña, "Little Joe" Acuña, Natcho Rangel, John Vigare, Abe Terrazone, Vic Yorba, and David Salazar. (Courtesy of Camilia Alva López.)

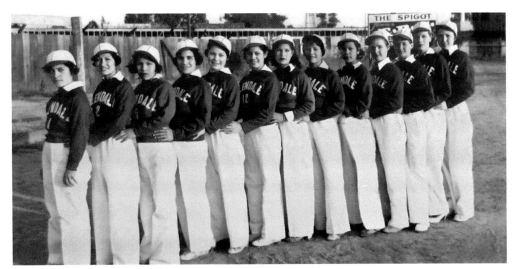

The 1935 Glendale Spanish American Civic Club played at Glendale High School. Emma Pérez (fifth from front) was born in Phoenix, where her father worked as a dairy milker with other Mexican laborers, in 1919. Her family later moved to Glendale, California, where she was selected to play for a professional team since she was an exceptional pitcher and shortstop. However, her father could not find the tryout location, and thus, she lost her opportunity to play professionally. She raised three children. (Courtesy of Vincent Pérez.)

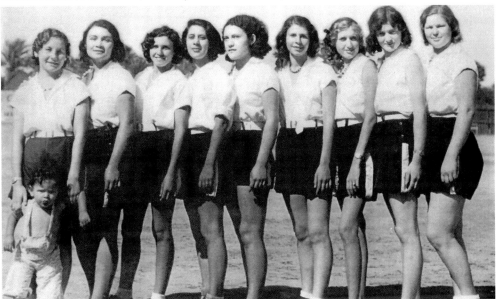

This c. 1947 photograph was taken in the Pecan-Utah section of East Los Angeles. Post–World War II housing and a nearby community college were built in the neighborhood for returning veterans. The team manager was Manuel Regalado, who coached several teams throughout Los Angeles over the years. Two of the players are Mary Talvera (third from left) and Annie Faldman (fourth from left). Regalado asked famed photographer Dick Whittington to take this photograph. (Courtesy of Ron Regalado.)

This 1950s photograph was taken at Belvedere Park of the Péna brothers and their father, William, who managed them. At this particular game, one of the brothers did not show up on time so his father looked into the stands and spotted Wally Poon (one of the best players in Los Angeles) and asked him to play instead. Prior to the game, the players took a team photograph. The Péna brothers and their dad personalized the photograph to Wally Poon making him an honorary Péna. (Courtesy of Richard Péna.)

Players of this era were grateful to the coaches, baseball scouts, former ballplayers, teammates, friends, and family members who shared with them the love for baseball. This 1950s Carmelita Provision Company team at Evergreen Park included three of the famous Péna brothers, John, Richard, and Gabe. (Courtesy of the Péna family.)

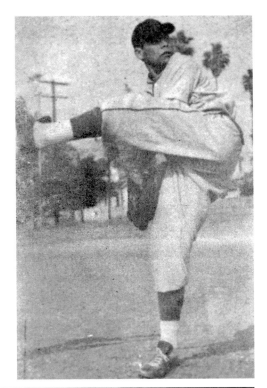

This 1946 photograph shows Al Padilla in his famous wind-up for the curveball. Roosevelt High School, located in East Los Angeles, played in the Dorsey High School Tournament that determined the Los Angeles City Championship. Roosevelt won the Division II title with Padilla the winning pitcher. He later coached high school and college baseball and football. In 1970, he was inducted into the Occidental College Football Hall of Fame. His 1974 East Los Angeles College football team won the California State Championship. He retired after 43 years of coaching and teaching to golf and spend time traveling with his wife, Dora. (Courtesy of Al Padilla.)

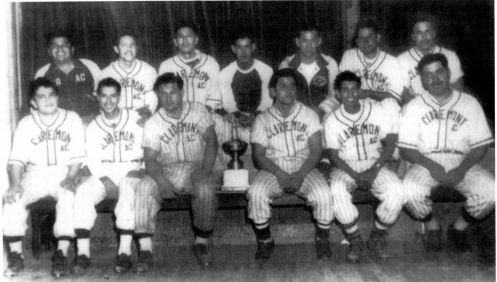

This c. 1949 photograph of the Claremont Athletic Club includes many World War II veterans. From left to right are (first row) Vincent Álvarez, Joe Félix, Peter Belmúdez, Al Villanueva, Raymond Guerrero, and Ramón Sevilla; (second row) Ben Molina, Paul Gomez, George Encinas, Fred Gomez, Raymond Gonzáles, Roman Salazar, and Tony Gomez. George Encinas, along with his brothers Maury and Tommie, dominated baseball and softball in the Pomona Valley for decades. (Courtesy of Gilbert Belmúdez.)

The legendary Bob Holmes coached the 1953 Garfield baseball team. The team included Joe Gaitán, All-Southern League Player of the Year; Tom Robles and Angel Figueroa, first team, All-City; Clarence Savedra; and Glenn Dangleis, second team, All-City. Angel Figueroa, Tom Robles, and Pete Ortega all played for the Pittsburgh Pirates minor league system. Fred Scott played at East Los Angeles College and the University of Southern California and signed with the Baltimore Orioles, playing in their minor leagues. (Courtesy of Fred Scott.)

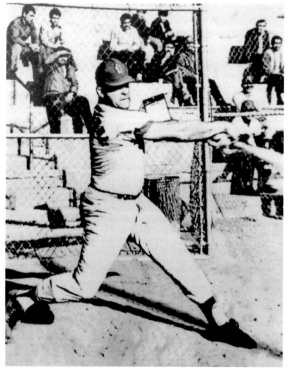

Mike Brito, pictured at Fresno Park, was born in Cuba. He was playing in Mexico in 1955 when he signed with the Washington Senators. He played five years of baseball and later was hired as a scout by the Dodgers. Brito signed Robert "Babo" Castillo from Lincoln High School and Fernando Valenzuela. In 1968, he established the Mike Brito League, which is now in its fifth decade. His friend Orlando Cepeda of the San Francisco Giants gave the cap Brito is wearing to him. (Courtesy of Mike Brito.)

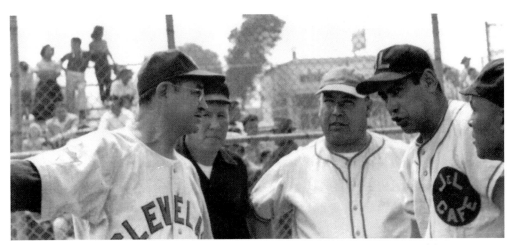

Team managers and umpires go over the ground rules at Evergreen Park in an old-timers' game in 1956 between Los Angeles and El Paso, Texas. The manager for the Los Angeles team was Manuel Regalado, shown here wearing a Cleveland Indian jersey. The umpire was Pete Barrios on the far right. Barrios played ball for years as an outstanding switch-hitting catcher. He later became an umpire with the Los Angeles Municipal League and officiated at Evergreen, Fresno, and Maravilla parks. (Courtesy of Ron Regalado.)

Tony Lugo played for several semiprofessional teams in East Los Angeles, including pitching for the Aguilas (Eagles) at Evergreen Park. He is seen here in 1962 with his two sons Raymond (batting), now a Los Angeles deputy sheriff, and Richard, now an Orange County deputy sheriff in Santa Ana. Players often took their sons with them to Sunday games. Boys developed their baseball skills in throwing warm-up pitches and catching outfield flies during batting practice and serving as batboys. (Courtesy of Richard Lugo.)

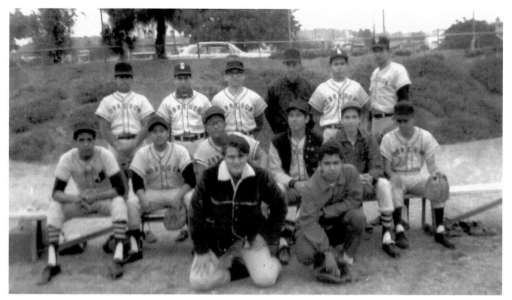

The 1960s Obregón team played its home games at East Los Angeles Community College. The coach was Mexican American Jess Hunter. Baseball was one of the few positive activities that kept many young men out of gangs. The team played against Southgate, Los Angeles, Huntington Park, Lynwood, Montebello, and Alhambra. The team had several exceptional players, including Sergio Hernández, Rich López, and James Retana. (Courtesy of Sally Hernández.)

Marcelo Olivares Gámez joined several company teams, including the Carmelita Chorizeros and Clifton Cafeteria, after serving stateside during World War II delivering P-38 planes as a teamster. Marcelo Gámez's children have carried on his tradition, with Lillian playing softball at Bishop Conaty Catholic High School, Ted umpiring for 22 years, Tony playing in high school, and Ernie playing both in high school and the armed forces.

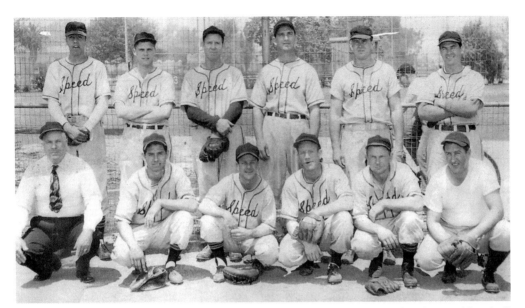

Of Marcelo's six children, Gilbert (second row, far left) enjoyed a lifetime of professional baseball activities. Gilbert is seen here with the 1952 Speed team playing against the Eastside Beer Club in Riverside. His friend Gilbert Blanco (first row, second from left) had a successful career playing for Chopoline Shoe Store, Ornelas Market, Eastside Beer of Los Angeles, Carmelita Chorizeros, the Bakersfield California League, and the Texas-Arizona League with the Douglas, Arizona Copper Kings. Blanco was once voted MVP with Carmelita. (Courtesy of Alma Gámez.)

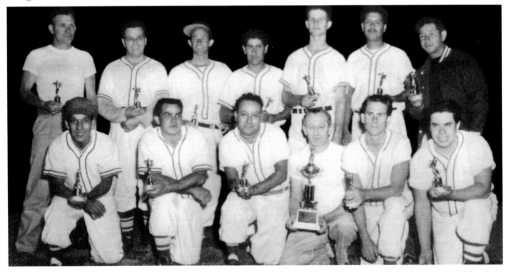

The 1955 Ontario team was sponsored by Jalisco Market and organized and managed by Joe García, who played ball in Pomona before World War II. Players made a baseball diamond out of an old sandlot field. Players included Gil Guevara (first row, far left), Joe García (first row, third from left), Joey Fuentes (first row, far right), Charlie Águilar (second row, second from left), Ed Jiménez (second row, second from right), and Frank Hernández (second row, far right). Joe García married Gil Guevara's sister Katie. (Courtesy of Richard García.)

Mexican American baseball in La Verne can be traced to the 1930s. Games were played at Palomares School, a segregated school for Mexican American children. Manuel Romo remembers his father, Isador Romo (wearing the sombrero), managing the La Verne Merchants. He fondly recalls that both of them watched Sunday afternoon games under an oak tree, sitting on orange crates sharing burritos and drinks, after his father retired from managing. Charlie Rodríguez, known as "La Tortuga" (the turtle), coached the Merchants in the 1940s. (Courtesy of Dennis Duke Romo.)

The 1962 Los Angeles Chihuahua team was typical of teams who named themselves after their hometowns in Mexico. Several players had played ball in Mexico. Oscar Chacón (second row, fourth from left) had been a batboy for a Chihuahua team in Mexico that included player Mike Brito, later a famous Dodger scout. Chacón recalled playing against Brito later in Los Angeles. Chacón was an outstanding hitter and batted cleanup. He eventually passed on his baseball knowledge to his children and grandchildren. (Courtesy of Oscar Chacón.)

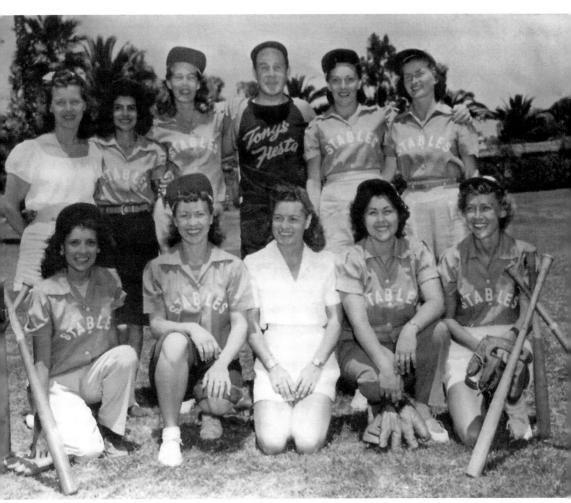

Catalina Island has had a long and rich Mexican American history. This team includes three Mexican Americans, Tina Saucedo Voci (first row, far left), her sister Lucy Saucedo McLeish (second row, second from left), and Lorraine Herrera (first row, second from right). Mexican American women played several positions and were very competitive; therefore, they were highly sought after by Anglo teams. The team was named the Stables; its sponsor rented horses to tourists. (Courtesy of Marcelino Saucedo.)

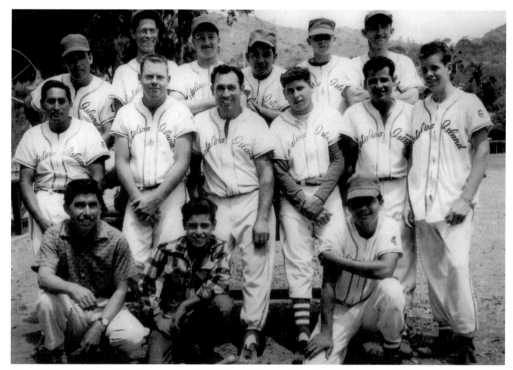

The 1952 Catalina Island team included Lipe Hernández (first row, far right), Jim Félix (second row, far left), Joe Saldana (second row, fourth from left), and Joe "Foxie" Saucedo (second row, second from right). Foxie, who pitched and played shortstop, earned his nickname for all the bases he stole. His brother Marcelino was an outstanding player, who later coached for the Pittsburgh Pirates. The batboy is Gil Voci (first row, middle), who scored 60 points in a high school basketball game. (Courtesy of Marcelino Saucedo.)

Managers of the Los Angeles Municipal Baseball Association played their annual game at Evergreen Park in East Los Angeles on Cinco de Mayo (May 5). This 1968 photograph includes Tom Pérez (standing second from right with dark glasses), whose distinguished career included his involvement with the Los Angeles Municipal Baseball Association and the Los Angeles County Baseball Museum Hall of Fame. Tom worked as a security guard on the hit show *Cheers* and coached the cast softball team. (Courtesy of Tom Pérez.)

The 1948 North Hollywood Vixies played at Las Palmas Park in San Fernando. From left to right are (first row) Jennie Díaz, Delores Moreno, Teresa Hernández, Chelo Ramírez (manager), Ramóna Valenzuela, Dolores Moreno, and Mary Hernández; (second row) Peggie Padilla, Lucy Castillo, Estella Quijada, Lupie Castillo, Rosie Chávez, Connie Lugo, and Julie Salazar. Valenzuela and Quijada played also at North Hollywood High School, the only Mexican Americans on the softball team. (Courtesy of Ramóna Valenzuela Cervantes.)

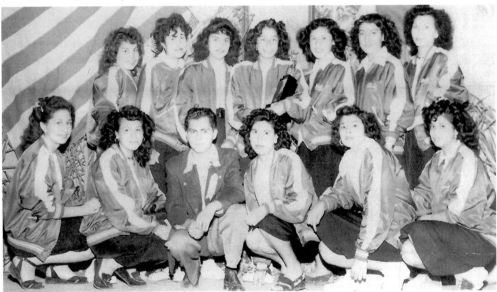

The San Fernando Blue Jays are shown here at the San Fernando American Legion Post on September 16, 1948. Led by star pitcher Isabel Vaiz, they won their league championship. Pictured are, from left to right, (kneeling) two unidentified people, Paul Veles (manager), ? Paz, Rachel Rúiz, and Sara Serrano; (standing) Chris Díaz, Benita Ramírez, Mary Tapía, Isabel Vaiz (holding her MVP trophy), Helen Landín, Licha García, and Rosie Imperial. The Blue Jays team sponsor was Family Grill. (Courtesy of Isabel Vaiz Mejia.)

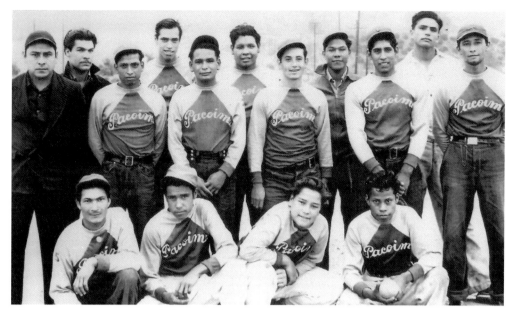

The 1936 Pacoima team includes, from left to right, (first row) Julian Almada, Joe Escalante, Louie García, and Jimmy Hernández; (second row) Chapo Yidal (umpire), Lupe Hernández, Pete Almada, Nacho Calzoda, and Joe Martínez; (third row) Joe Moreno, Albert Escalante, Jack Moreno, unidentified, and Eddie Prieto. In 1990, Pacoima Park was dedicated to World War II soldier and Pacoima native David M. Gonzáles. Gonzáles, who played at Pacoima Park, was awarded several medals, including the Purple Heart and the Medal of Honor. (Courtesy of Joffee García.)

The Burbank Alvarado Junior Merchants were champions of the Burbank Boys' League in 1950. Led by the battery of Mike Velarde (first row, third from left) and George Alvarado (first row, second from right), organized and managed by Hank Alvarado (second row, third from left), and sponsored by Karl's Shoes, the team was comprised of players from North Hollywood and Burbank. They played at Olive Park in Burbank. Other outstanding players included the following: Carlos Dávila, Manuel Díaz, John Lara, and Eddie Ordúñez. (Courtesy of Mike Velarde.)

Sergio Hernández (first row, third from right) played for Jefferson High School in 1938. Several major league teams had scouted Hernández before he entered World War II. He was killed at the Battle of the Bulge on his 21st birthday and is buried at the Luxenbourg American Cemetery. His sister-in-law Sally recalls seeing a major league contract awaiting his return from the service. Sergio's brothers Milo and Manuel also served during World War II. (Courtesy of Sally Hernández.)

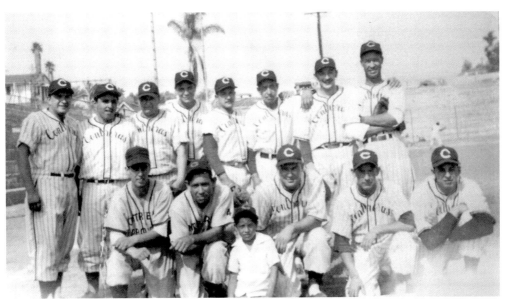

The Contreras Produce Company sponsored this East Los Angeles team at Evergreen Park in the 1950s. The team's outstanding players included two sets of brothers, Bobby, first row, far left, and Ernie Sanchéz, first row, just to the right of the young boy; Milo, second row, far left, and Manuel Hernández, second row, third from left. Al Machado, the manager, is in second row, third from right. (Courtesy of Sally Hernández.)

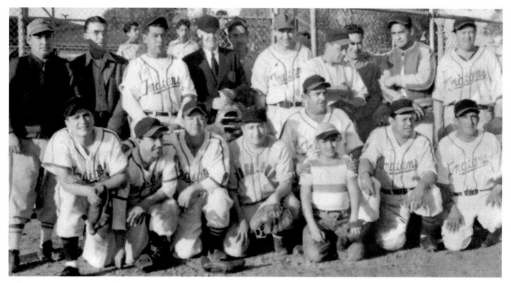

This 1950s team included brothers Milo and Manuel Hernández and brothers Bobby and Ernie Sanchéz. "Pops" Sanchéz (second row, second from left) was the father of Bobby and Ernie. Sergio Hernández remembers his father Milo's story about Ted Williams hitting a line drive to his dad at third base. Milo fielded it cleanly and threw Williams out. At the end of the inning, as he made his way to the dugout, Williams stopped the young Milo and said, "Good play, Kid!" (Courtesy of Sergio Hernández.)

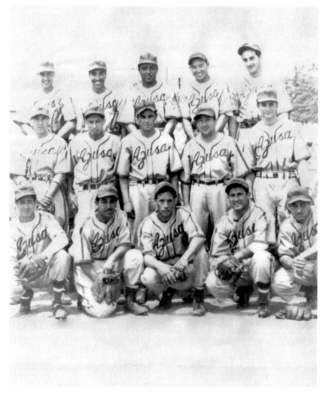

This c. 1948 Azusa team played at Memorial Park and was comprised of many World War II veterans. The team also featured players from Irwindale, including Mickey Silva and Mike Miranda. The catcher was Art Morales (first row, center), and the manager was Manuel Toledo (third row, center). His brother Henry Toledo (second row, second from left) was an all-around athlete and played several sports in the military. Mexican American communities in Azusa, Duarte, El Monte, Irwindale, and Baldwin Park formed an elaborate system of games, leagues, and championship tournaments. (Courtesy of Art Morales.)

COAST TO COAST

By the 1920s, Mexican American communities could be found in nearly every major region of the United States: the Southwest, the Pacific Northwest, the Rocky Mountains area, the Midwest, the Great Lakes region, the Deep South, and the East Coast. Mexican Americans were employed with the railroads, steel mills, packinghouses, icehouses, salt and cement mines, auto factories, agricultural fields, tanneries, loading docks, lumber mills, gravel pits, oil refineries, and nitrate plants. Many had come to the United States seeking steady work, physical security from revolution in their homeland, and a better future for themselves and their children. It took courage, hope, and fortitude to do what these individuals and families had done to migrate to a strange land. Other Mexican Americans had established family roots prior to the Mexican American War of 1848, some going back into the 18th century.

Wherever Mexican Americans settled, they immediately established an elaborate network of infrastructures that included mutual aid societies, religious associations, labor groups, the performing arts, Spanish-language newspapers and magazines, civil and political rights organizations, and sports. Sports, especially baseball, softball, basketball, and boxing, took on a special significance to the majority of the Mexican American population. At such gatherings, people socialized, discussed community issues, and strengthened their sense of racial and ethnic solidarity.

Many teams adopted revered names from their historical past, paying tribute to such cultural icons as the Aztecas, the Mayans, the Cuauhtémocs, the Águilas, the Guadalupanas, and the Yanquis. Some community teams named their ball fields El Parque Anáhuac (the Park of the Ancient Valley of Mexico). Their conscious choice of these and other historical names was their special way of respecting and promoting the Mexican culture and of publicly acknowledging their deep roots to the great indigenous civilizations of Mexico. The community leadership during the first 50 years of the 20th century understood that sports in ancient Mexico had played important social and political roles and that these 20th-century ball clubs desired to foster these same social and political roles in the United States. Regardless of where Mexican Americans lived, from Arizona to Pennsylvania, they shared much in common when it came to baseball.

Two-year-old John Ysidro Dickinson, born in Laredo, Texas, in 1908, wears a Laredo uniform made by his mother Cayetana Gutiérrez Dickinson. Johnny grew up playing ball for most of his 88 years in South Texas and Mexico. When major leaguers barnstormed through the Laredo area in pre–World War II years, Johnny pitched against Jimmy Foxx, Dixie Walker, Mickey Cochrane, and other major league players. Johnny also pitched against Dizzy Dean in the 1920s when Dean was stationed at Fort Sam Houston in San Antonio. (Courtesy of John Y. Dickinson III.)

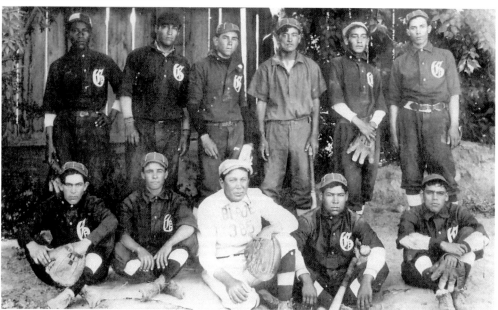

Manuel Padilla (first row, second from right) played for the Tucson Groves at Elysian Grove Park, now the site of Ochoa School. The ballpark was so small that people sat in their cars alongside both foul poles watching the game. Manuel was drafted out of Tucson High School by the Southern Pacific Railroad Company to play ball. This 1912 photograph at Randolph Park was taken prior to a game against a team of old-timers. (Courtesy of Al Padilla.)

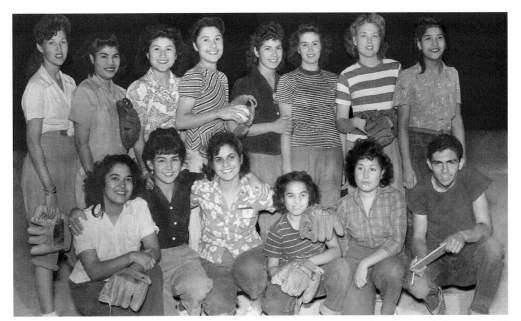

The Tucson Convair Queens, most of whom were employed by Consolidated Aircraft during World War II, practiced at Eagle Field around 1942. Eleven-year-old Grace Pellón (first row, third from right) shagged balls during practice and later volunteered to play catcher when no one else wanted the position. She played nearly 40 years and was inducted into the Southern Arizona Softball Hall of Fame in 1980. Some of her daughters, her granddaughters, and her great-granddaughter have followed in her softball footsteps. (Courtesy of Darcy Meyer.)

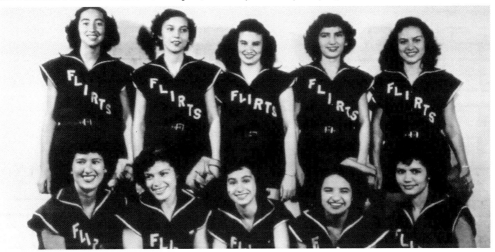

The Twenty-Second Street Flirts (1948–1956) joined the first Tucson, Arizona, city league in 1948, coached by Fabián Contreras and played games throughout the state. After home games, they loved dancing at the Casino Ballroom. The original Flirts included sisters Bertha (first row, center) and Esther Félix (second row, far left), Mary Grace, Lucy Dupont, sisters Delia (first row, far right) and Alice Reyna, Betty Mayer, Elma Padías, Gracie Pellón, and coach Fabián's wife, Nellie. (Courtesy of Norma Gallego.)

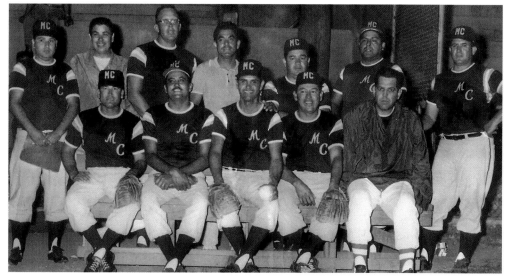

The Monte Carlo Men's team played in Tucson, Arizona, during the 1954–1955 season. Pictured are, from left to right, (first row) Mike McCoy, Richard Acedo, Fred Riesgo, Rudy Castro, and Art Kingman; (second row) Javier Yañez, Johnny Aguirre, Dean Metz, Drake Elías, Frank Cajas, Timo Luján, and Andy Herrera. Rudy Castro played at Tucson High School, Palo Verde Community College in California, the Pendleton Marine Corps team, and the University of Arizona. He later served nine years on the Tucson City Council. (Courtesy of Linda Ann Spencer.)

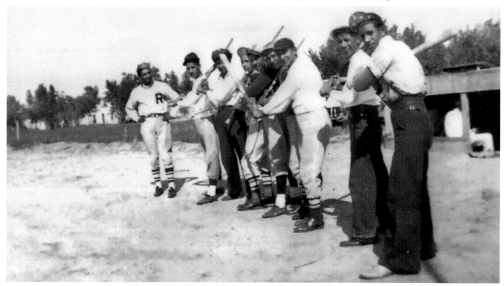

Players from Ovid, Julesburg, and Sterling, Colorado, played in Fort Morgan, sometimes taking three hours traveling to games. Since they could not afford uniforms, the wives made them. The players and wives worked in the sugar beet and potato fields. Times were tough, but the families found joy playing baseball on Sundays. From left to right in 1938 are Steve Ortiz, Ralph Guerra, Refugio Ortiz, Isaac Estrada, Sam Amador, Patricio Estrada, Lorenzo Ortiz, Johnny Ortiz, and Frank Estrada. (Courtesy of Virginia Mendoza.)

Friends and family of Patricio Estrada formed their annual Mexican American baseball team in Julesburg, Colorado, in 1940. They played against Nebraska teams from McCook, Ogallala, and North Platte and Colorado teams from Crook, Ovid, and Fort Morgan. The team included brothers Patricio, Frank, and Isaac Estrada and brother-in-laws Ralph Guerra and Sam Amador. Cesario Estrada (batboy) later played in Kansas City and earned Purple Hearts and Medals of Valor in Korea and Vietnam. (Courtesy of Robert Estrada.)

During the Great Depression, Mexican Americans from Texas, Kansas, Iowa, and Nebraska traveled to Utah, Idaho, Montana, Minnesota, and Wyoming seeking work. This photograph shows a pickup team comprised of players from Texas and Kansas taken in 1933 in Basin, Wyoming. After working hard in the fields all week, they still played two Sunday games. Like their counterparts elsewhere, they confronted racial discrimination in the workplace and in the public arena. (Courtesy of Andy Gutiérrez.)

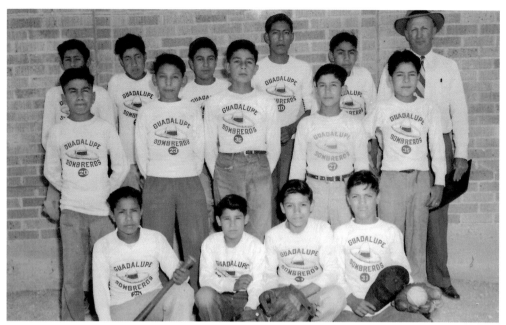

The Catholic Church was a major sponsor of youth sports, especially baseball and softball. Nearly every parish supported baseball and softball teams with fields, equipment, and uniforms. Mexican American teams were often referred to as Las Guadalupanas, named after Our Lady of Guadalupe, the Sacred Mother. The team shown above is the Guadalupe Sombreros from Houston, Texas, while the team shown below is the Guadalupe Greyhounds from Amarillo, Texas. Amarillo Borger Express sponsored the Greyhounds. Pictured below are, from left to right, (first row) Louis Flores, Henry Alonzo, Ruebén Palacio, Paul Rodríguez, and Nars Solíz; (second row) Benny Campos, Carlos Alonzo, Alex Tenorio, and Sammy Morín. (Courtesy of the Southwest Collections/Special Collection Library Texas Tech University, and David Flores.)

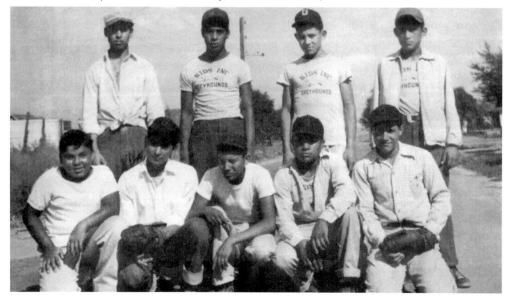

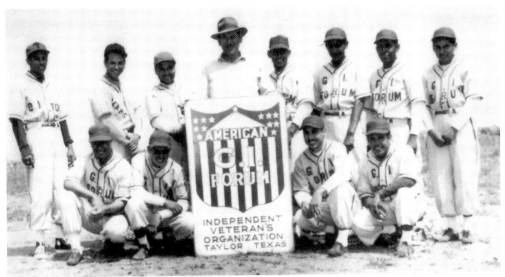

The post–World War II period witnessed the establishment of the American GI Forum in Texas in 1948. Many returning Mexican American veterans confronted discrimination in their hometowns, despite fighting and dying for their country. Approximately 500,000 Mexican American men and women proudly served in the armed forces while thousands of others worked in defense plants at home. Mexican Americans were the most decorated group, including 14 Medal of Honor recipients. By the 1950s, the GI Forum had spread to 23 states—with nearly 50 chapters in Texas alone—with 10,000 members. The GI Forum promoted baseball as a means to keep youth away from trouble, keep families together, and foster community pride. This photograph is of a team from Taylor, Texas. (Courtesy of Texas A&M University-Corpus Christi Bell Library.)

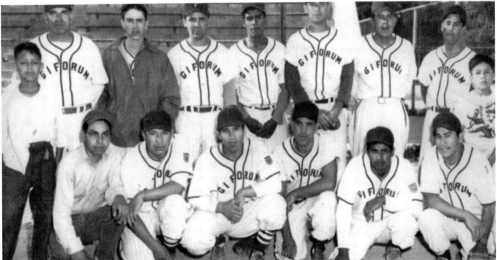

This GI Forum team represents the State of Colorado and was one of several GI Forum teams established throughout the United States. The teams were generally comprised of World War II and Korean veterans along with younger players. The GI Forum teams in Texas, Nebraska, and Kansas were considered among the best ball clubs within the Forum.

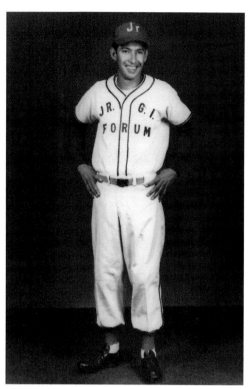

This photograph is of Jesse Rivera, national Junior GI Forum president and a member of the Junior GI Forum team in Corpus Christi. The forum sponsored both boys' and girls' teams. (Courtesy of Texas A&M University-Corpus Christi Bell Library.)

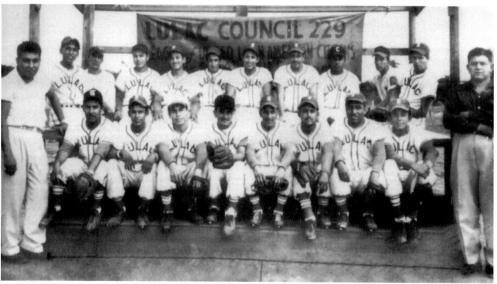

The League of United Latin Americans Citizens (LULAC) was established as a civil rights organization in Texas in 1929. This photograph shows the 1953 Bryan, Texas, LULAC Council No. 229 team. From left to right are (first row) coach Daniel Rúiz, Joe Alvarado, Pete Ramírez, Paul Quintero, Joe Guerra, Fred Franco, Tico Ramírez, Soltero Gebara, Eugene Cordero, and coach Lolo Méndez; (second row) Joe Ramírez, Joe Estrada, Pete Lara, Phillip Cruz, Marshall López, Ray Castro, Charlie Guerra, Pete Ortiz, Joe Flores, and Ray Portal. (Courtesy of Lionel García.)

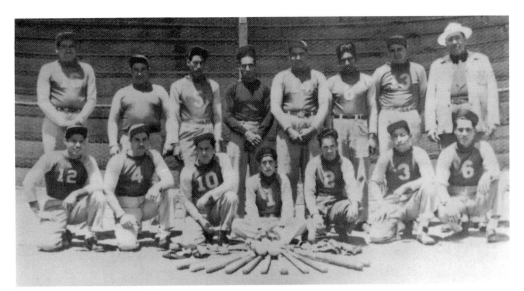

The 1946 Garden City, Kansas, team played at Finney Park. Veterans' groups, including the American GI Forum, Mexican American Veterans Clubs, the American Legion, and Veterans of Foreign Wars, sponsored teams. Pictured are, from left to right, (first row) Jesse Ávila, Almer Martínez, Ignacio Ávila, Willie Gonzáles (batboy), Jessie Orozco, Albert Mesa, and Leo Cervantes; (second row) Rudy Ramírez, Santigio Ramírez, Joe Cervantes, Leonard Perales, Hank García, Andrew Guerrero, William García, and Lupe Guillén (with white hat).

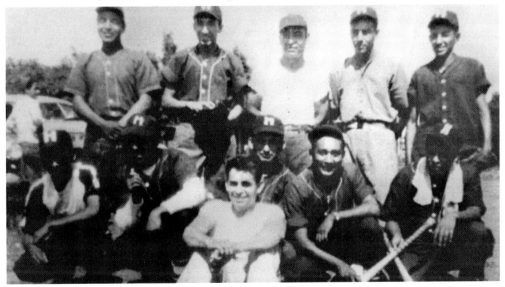

Mexican American teams in Hutchinson, Kansas, date back to 1929 with Los Lobos (the Wolves). Games were played on cow fields affectionately known as Las Vegas (the Pastures). One of the best players was Matt Hernández (first row, second from right). Hutchinson played Mexican American teams from Lyons, Dodge City, Newton, and Wichita. In 1938, a Mexican American softball tournament was held that included teams from Wichita, Hutchinson, Salina, Newton, Kanapolis, and Lyons. The press reported huge crowds for the games. (Courtesy of Matt Hernández.)

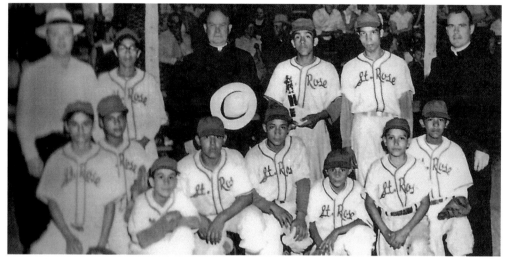

Fr. Michael Leis formed a team at St. Rose Church in Wellington, Kansas, in 1949. In 1950, the team traveled to Independence, Chanute, Coffeyville, and Parsons. That same year, the St. Rose team won the Wichita Diocese Championship. Players include Henry Reyes, Jesse and Robert Jaramillo, Sebastián Macías, Manuel Jiménez, Julio Caudillo, Sebastián Ramírez, Manuel Venegas, Manuel Lira, Alfonso Ybarra, and Magdaleno Abasolo. There had been a 1930s team known as the Wellington Mayans. (Courtesy of Veronica Triana.)

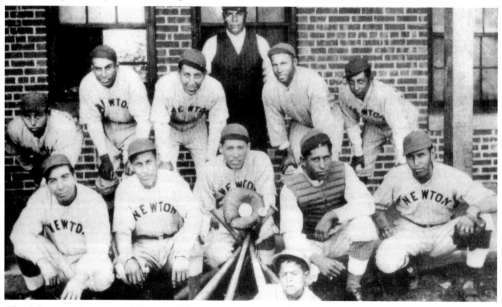

The Mexican American Newton, Kansas, community formed its first baseball teams nearly 100 years ago. This photograph is of the 1932 Cuautemoc team. Shown are, from left to right, (first row) Angel Ávila (batboy); (second row) David Cebellos, Epifanio Arellano, Frank Lujano, Ramiro Carrión, Ramón Pedroza; (third row) José Cuellar, Juan Arellano, Ramón Hernández, José Ávila (manager), Raymundo Jaso, and Martín Sauceda. In 1993, the Newton Fiesta Committee paid tribute to the history of sports in Newton. (Courtesy of Ray Oláis.)

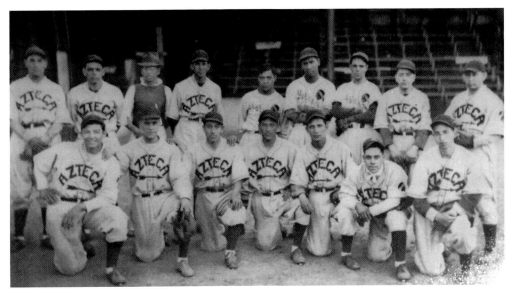

The 1930s Azteca baseball teams from Kansas City, Kansas, played in the Argentine and Armourdale communities. This team had outstanding players, including Manuel Abarca (first row, third from left), Carlos Móntez (first row, fourth from left), Tony Cecena (second row, third from left), Marcelino Fernández (second row, fourth from left), Charlie Móntez (second row, fifth from left). The manager was Manuel Zúñiga (first row, far left). Fernández was an exceptional pitcher and first baseman. (Courtesy of Nellie Fernández Allen.)

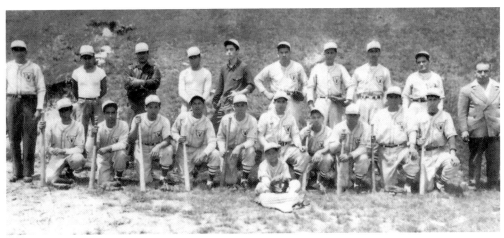

La Unión Cultural Mexicana (UCM) sponsored the Wildcats in 1949 in Kansas City, Missouri. The team members are, from left to right, (first row) J. Aldaco Jr. (batboy); (second row) John Aldaco (manager), Charles Estrada, George Guerra, P. Acosta, C. Moreno, M. Guerra, A. Martínez, T. Montoya, R. Fernández, J. Ibarra, J. López, and Manuel Cervantes (business manager); (third row) M. Castro, G. Arrajo, J. Ramírez, A. Carrillo, N. Hernández, I. Estrada, R. Guerra, and F. Madellín. (Courtesy Virginia Estrada Mendoza.)

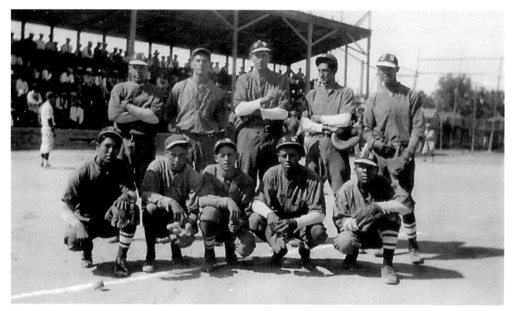

Sugar beet companies commissioned labor agents to recruit Mexican workers from Kansas City and Omaha and transport them to western Nebraska. Mexican communities sprang up in Lyman, Morrill, Mitchell, Gering, Scottsbluff, Bayard, Minatare, Alliance, and Bridgeport. Not surprisingly, these towns formed baseball teams. This photograph of Los Zorros (the Foxes) was taken at the Bayard ballpark in 1930 during the September 16 Mexican Independence festivities. Players include brothers Johnny Mack (first row, far left) and Mike Hernández (second row, second from right), Ben Rojas (second row, center), and Pat Dominquez (second row, far right). (Courtesy of Eduardo Hernández.)

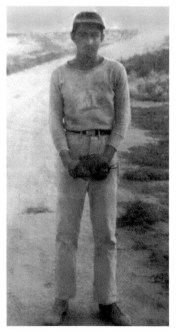

Eduardo Hernández, whose father played catcher for Los Zorros, loved playing baseball. This photograph shows him at 13 years old leaving the sugar beets fields and heading to practice at Cleveland Field in Scottsbluff, Nebraska. He played first base on the Junior American Legion team and went on to play freshman baseball at the University of Nebraska. His sons and grandsons continue to play baseball, with one of them receiving a scholarship to the University of Kansas and another being invited for a tryout at California State University at San Francisco. (Courtesy of Eduardo Hernández.)

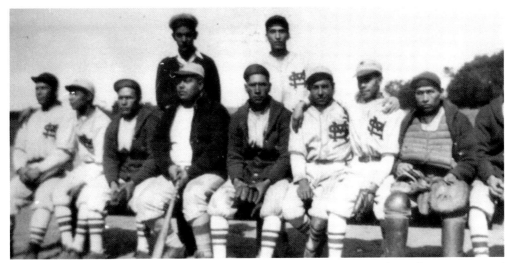

The Quad-Cities of Davenport and Bettendorf, Iowa, and Silvis and Moline, Illinois, organized the first Mexican American baseball team known as the Mexican All-Stars (1923–1928) from Silvis, Illinois, founded by Philipe Terrónez. Half of the team played musical instruments with the well-known concert band Corporación Musical Miguel Hidalgo from Silvis. Outstanding players included Cruz Sierra, Isaac Rangel, Manuel Sierra, Socorro Natche, Jesse Castilla, Lewis Sierra, Cleófas Rangel, and Eletorio and Augie Martel. (Courtesy of Augie Martel.)

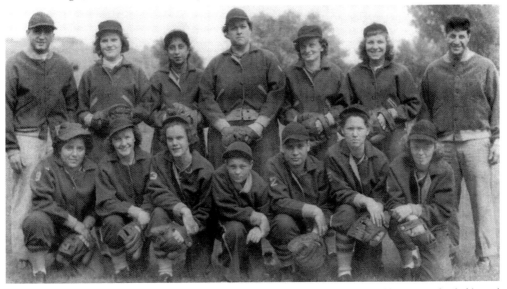

The Eagle Market Superettes included sisters Juanita Mary Conchola (first row, far left) and Margaret Macías (second row, third from left). This team represented Iowa in the National Softball Congress World Championships in 1949. Juanita worked at an ammunition plant and joined the Women's Army Corps (WACS) in 1943. She played shortstop, beating their female rivals from the Navy, Marines, and Air Force. She received an honorable discharge as a sergeant with several medals, including Good Conduct, American Theater Ribbon, World War II Medal, and Drivers Medal. (Courtesy of Juanita Conchola.)

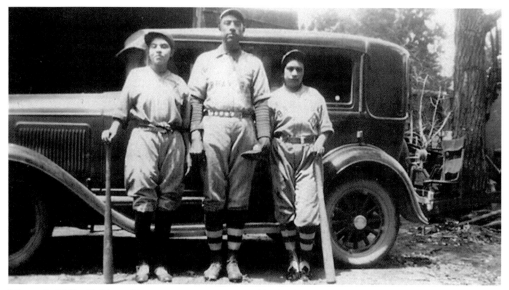

Manuela Villa (left) and her cousin Gregoria Villa (right), wearing uniforms borrowed for this photograph, are shown with their uncle Agapito Villa in Las Animas, Colorado, around 1920. The Villa family had arrived from Mexico around 1903 and worked as miners and steelworkers throughout Colorado. The family was athletic and loved playing baseball. Sadly, Agapito was killed in an industrial accident in 1939. Agapito and his extended family were members of La Alianza Hispano Americano, a mutual aid society promoting civil, political, and labor rights. (Courtesy of Roberta H. Martínez.)

The early Mexican community in South Chicago was located east of the railroad tracks. Mexicans worked at the railroads and steel mills. At the center of the Mexican community was Our Lady of Guadalupe Church. Since the early 1920s, South Chicago has produced numerous Mexican American teams. Teams were sponsored by schools, churches, small and large businesses, community organizations, neighborhood clubs, and local taverns. Pictured here in 1937 is the Yaquis team. (Courtesy of Southeast Chicago Historical Society.)

This photograph, taken in 1926, is of the Mayas Sports Club at Bessemer Park. Bessemer was the closest park to the South Chicago Mexican community and had several baseball leagues. In South Chicago, neighborhood sports were a means of cultural assimilation and "Americanization" for new immigrants. (Courtesy of Southeast Chicago Historical Society.)

Mexican baseball in Chicago dates back to the 1920s when Los Aztecas de Chicago drew thousands of fans. This 1960s Monterey team played its games in the Pilsen Mexican American community. They won the championship of Chicago's Liga Mexicana in 1964–1965. Brothers Francisco Pulido (first row, second from left) and Gregorio (second row, fourth from left) were from Monterey, Mexico. In 1952, they arrived in Chicago to rejoin their family, which included four siblings born in the United States who had been repatriated to Mexico during the Great Depression. (Courtesy of Antonio Delgado.)

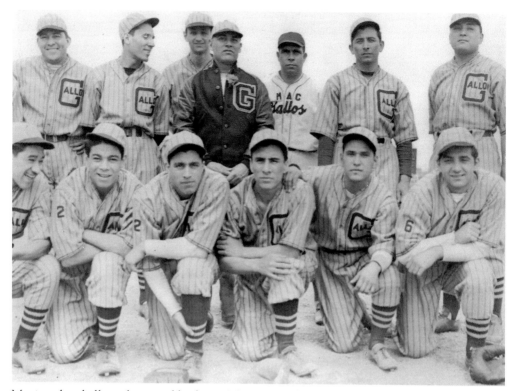

Mexican baseball can be traced back to 1917 in East Chicago, Indiana, where an early ballpark seated 500 fans, and local merchants donated funds for attractive uniforms and equipment. The 1920s teams, such as Los Obreros de San José, Las Águilas, La Junta, and El Club Azteca, brought joy and honor to the "harbor" community. This photograph taken in the late 1930s shows Los Gallos (the Roosters) team. Players included Fred Luna, Henry and Angelo Muchuca, Cipiano Hernández, Joe González, Joe Flores, Benny Ortega, Joe Alamillo, Leo Hernández, and Félix Pérez. (Courtesy of Louis Vásquez.)

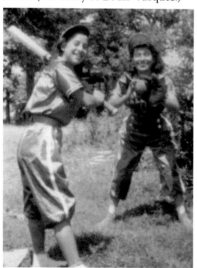

The Lady of Victory Sodality softball team was an all-Mexican, young girls' team from Our Lady of Guadalupe Church in East Chicago, Indiana. Since they played on the same day and on the same field as the boy's team, Los Gallos (the Roosters), the girl's team became known as Las Gallinas (the Hens). Seen here warming up before a game in 1938 are Maggie Garcia batting and Juanita Vasquez catching.

Margaret Villa sits between two great Hall of Famers, Connie Mack (left) and Al Simmons. It is believed that she was the only Mexican American woman who played for the All-American Girls Professional Baseball League. This photograph was taken in 1946 when Villa played shortstop for the Kenosha Comets. She also barnstormed with the All-Star team throughout Cuba, Mexico, and South America. On June 9, 1946, she drove in nine runs and collected 11 total bases, league records that never would be surpassed. (Courtesy of Margaret Villa Cryan.)

Angie Ramos, who worked in a Milwaukee garment factory sewing jackets, is pictured second row, fourth from left, in this 1943 photograph of all-stars from women's baseball teams sponsored by the International Ladies Garment Workers Union, founded in 1900 (Courtesy of the Latino Historical Society of Wisconsin.)

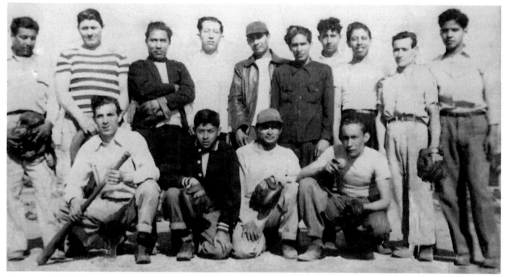

During the 1940s, softball teams and tournaments flourished throughout Michigan, Indiana, Ohio, and Illinois, where veterans' groups sponsored many Mexican American teams. Michigan teams were established in Adrian, Flint, Detroit, Lansing, Emily City, Saginaw, and Port Huron. In the city of Pontiac, the two teams were the Los Mayans and Los Aztecas. Michigan teams often traveled to neighboring Ohio, playing Mexican American teams from Toledo, Bowling Green, and Cleveland. This 1946 Latin American Club team represented the community of Ecoarse near Detroit. (Courtesy of Aniceto Rodríguez Muñiz.)

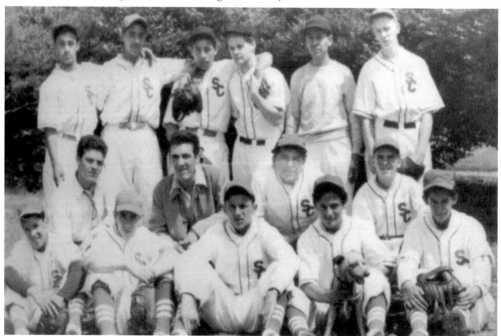

Antonio Lozano (standing second from right) enjoyed coaching boys in the neighborhood, including players on this Detroit baseball team. (Courtesy of Ray Lozano.)

FIELD OF DREAMS

On August 1, 2012, the Latino Baseball History Project sponsored its Fourth Annual Baseball Reunion on the campus of California State University, San Bernardino. These reunions bring together players and their families to remember and pay tribute to long-ago players and teams that brought so much joy and honor to their fans and families. There is music, food, speakers, library exhibits, book signings, and the collection of additional photographs for future publications, library exhibits, and documentaries. At each reunion, a few families generously donate uniforms, equipment, and other precious memorabilia to the project.

The project has been actively involved with several important events and activities. One of the most popular events has been the first-pitch ceremony, where players or family members are asked to participate in tossing the first pitch prior to a college or professional baseball game. Family members, friends, and neighbors are drawn to this wonderful event to see former players once again take to the field, sporting their worn gloves and caps, and throw out the first game ball. For many of these players, it has been over 50 years since they were on a baseball diamond in front of their adoring fans. For grandchildren and great-grandchildren, it is a rare opportunity to take photographs with their baseball elders.

The project has also sponsored several significant library exhibits highlighting the extraordinary history of Mexican American baseball and softball with photographs, uniforms, and other vintage memorabilia. These exhibits have showcased particular players such as José G. Felipe from Orange County, Jim "Chayo" Rodríguez from the Inland Empire, and the famous Peña brothers of East Los Angeles. In the spring of 2012, California State Polytechnic University, Pomona hosted an exhibit titled "A League of Their Own: Mexican American Women and Softball, 1930s to 1950s," and a luncheon was held there to honor these extraordinary women and one of their coaches.

In the film *Field of Dreams*, the voice-over promises that if "you build it, they will come." The project is building a "field of dreams," and hundreds have already come to relive their baseball and softball glory days one more time.

On March 13, 2011, a ceremony was held at Belvedere Park in East Los Angeles honoring Manuel "Shorty" Pérez, longtime baseball manager. A memorial plaque highlighting his 35-year career (1947–1981) was unveiled. Los Angeles County supervisor Gloria Molina is seen here standing to the right of the plaque, along with a little league team. To her right is Armando Pérez (no relation to Manuel), and to his right are Gilbert and Lucille Pérez, son and daughter-in-law of Manuel Pérez.

Standing at home plate at Belvedere Park in East Los Angeles in 2011 are four of the famous Pena brothers. From left to right are Gabe, Richard, John, and Pete.

On May 29, 2012, California State University, Pomona honored women and coaches who played and managed softball. A library exhibit titled "A League of Their Own: Mexican American Women and Softball, 1930s to 1950s" was sponsored by the university's ethnic and women's studies. The exhibit included over 40 vintage photographs and other memorabilia. Each participant received a certificate congratulating her as pioneers of Mexican American softball. A panel of players then discussed how softball had shaped their personal, professional, and political lives. Below, participants throw out the first pitch. (Both, courtesy of Roe Wintherspoon.)

On June 16, 2012, Claremont celebrated the 40th anniversary of El Barrio Park and the centennial of Claremont's Mexican American community. The program included an indigenous spiritual procession, entertainment, a mass, a salute to war veterans, and a tribute baseball and softball teams. Los Angeles County supervisor Gloria Molina and California State senator Gloria Negrete-McLeod presented the community with proclamations. Several players and family members participated in the first-pitch ceremony. (Courtesy of Susan Brunasso.)

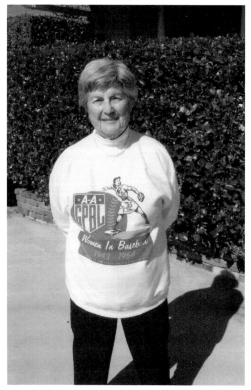

Margaret Villa Cryan enjoys attending reunions of the All-American Girls Professional Baseball League Players Association held every few years at the Hall of Fame in Cooperstown, New York. Margaret is part of the Women in Baseball permanent exhibit and has been invited to talk about her experiences with the league during her tenure from 1946 to 1950. She spends countless hours responding to request for her autographs. Prior to playing for the Kenosha Comets, she played a few years for the Orange County Lionettes.

On July 14, 2012 a book-signing event was held in Modesto. Mexican American baseball and softball were played in Visalia, Stockton, Fresno, Tulare, Riverbank, Tracy, San Juan Bautista, Salinas, Hollister, Gilroy, San José, and Watsonville. There are four former players in this photograph; they are Louie Jiménez, Gustavo Rodríguez, Cesario Estrada, and Patricio Rodríguez. Other family members represented Jesse Ulloa and departed players Jess Pérez, Lupe Pérez, and brothers Evaristo and Floratino Esquiel. Evaristo was the manager of the 1934 Riverbank Merchants and Floratino a player.

The Sacramento Mexican American community established the Mexican American Hall of Fame in 1972. On July 15, 2012, former players and families brought photographs and other memorabilia dating back to the 1930s. Pictured are, from left to right, (first row) Alan O'Conner, Cuño Barragán, Eddie Cervantes, Joe Duarte, and Hank López; (second row) Julius Reséndez, Jim Fellos, Eric Cervantes, Dick Alejo, Ernie Cervantes, Tom Crisp, and Pete Campos.

San Fernando Valley communities have fielded outstanding teams from San Fernando, Burbank, Pacoima, Glendale, Canoga Park, Arleta, North Hollywood, Reseda, Sun Valley, and Sylmar. Seen here at the East Valley Pony League in North Hollywood are, from left to right, Mike Velarde, Anthony Servera Jr., Anthony Servera Sr., Freddie Carrizosa, and Joffee García. The league, then known as San Val Little League, dedicated a field to Tony Servera Sr. on July 4, 1965. The field was rededicated to the Servera family in March 2008.

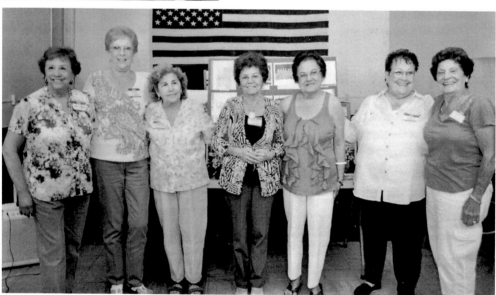

On July 8, 2012, a book-signing event was held at the Joe Domínguez American Legion Hall in Corona. The huge turnout included members of the 1930s, 1940s, and 1950s Athletics and Merchants teams and the 1940s and 1950s Debs and Royals, which were women's teams. Players, family members, and friends renewed old friendships and recalled their baseball and softball heroics. Pictured are, from left to right, Gloria Mendoza Salgado, Gloria Lunetta, Katherine Delgadillo Martínez, Dolores Delgadillo Aguilera, Anita Hernández Santana Martínez, Norma DeLeo, and Phyllis Bruno. (Courtesy of Brandi Berry.)

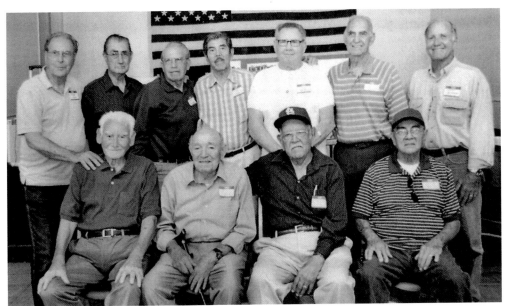

In this photograph are, from left to right, (first row) Chano Ortiz, Louis Luna, David Becerra, and Pete Martínez; (second row) Ángelo Lunetta, Carlos Uribe, Mitch Salgado, Ray Delgadillo, Bob Stark, Joe Uribe, and Larry Schimpf. Like many teams of their era, most were military veterans. (Courtesy of Brandi Berry.)

A book-signing event on July 29, 2012, in Rancho Cucamonga honored and acknowledged former players for their baseball contributions. Shown here are, from left to right, (first row) Pete Barrios Jr., Al Vásquez, Maury Encinas, Tommie Encinas, Bob Durán, and Bob Lagunas; (second row) John Hernández, Ray León, Rudy Leos, David Salazar, Gill Candelas, Chico Briones, Bob Ceballos, José G. Felipe, Tin Vásquez, and John Vásquez. (Courtesy of Anthony Vásquez.)

In August 2012, former players from the Inland Empire were honored at a book-signing reception at the legendary Mitla Café located in San Bernardino's historic Westside barrio. The Mitla Café is one of the oldest Mexican restaurants in California, dating back to 1937. It sponsored teams

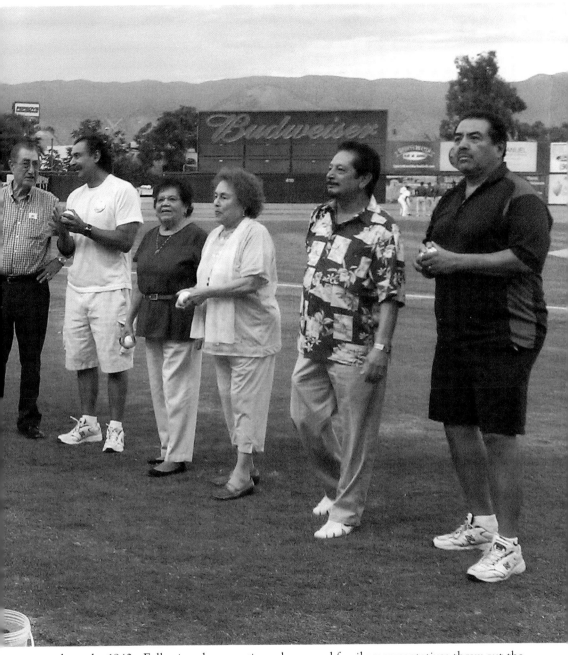

as early as the 1940s. Following the reception, players and family representatives threw out the first pitch at the Inland Empire 66er's San Manuel Stadium in San Bernardino. The 66ers are a minor league team for the Angels.

The Pico Rivera Go-Getters were formed in 1991 and now have four senior teams. Having won numerous tournaments, the Go-Getters consist of players ranging in age from their 70s through their 80s. The following players, from left to right, represent the four teams: (first row) Reyes Bueño, Yoko Cochran, Enrique Célis, Linda Rangell, Earleen Jiménez, Rudy Cásas, and José Romero; (second row) Ángel Rivera, Nora Morales, Dee Quezada, Augie Quezada, Phil Aguilera, Ernie Domínguez, Lorenzo Sánchez, and Manuel Hernández. Casas has been the coach and league coordinator since 1992. (Courtesy of Rudy Casas.)

Three generations of the Marcelino Rios Fernández family of Kansas City, Kansas, hold a photograph of Marcelino and his Mexican American Sports Hall of Fame induction plaque. His family members are, from left to right, (first row) great-grandchildren Jackson Willis, Jackie Pórraz, Veronica Ruiz, Elizabeth Ruiz, and Daniel Rodríguez Jr.; (second row) grandchildren Jenee Jóles Workman, Javier Pórraz Jr., Roberta Allen, Juan Pórraz, and Mike Ruiz Jr.; (third row) children "Peachez" Jóles, Mary Alice F. Pórraz, Mike Ruiz Sr., Nellie F. Allen, and Frances Ruiz Ard. (Courtesy of Arabel Pórraz.)

On August 11, 2012, a reunion was held at the home of Jim and Gloria Segovia in the city of Orange to salute members of the La Jolla Kats, a team from the 1940s and 1950s. Shown are, from left to right, (first row) Elida Solórzano, Marcela Venégas Sandoval, Lupe Castro Palacio, and Seferina Álvarez García; (second row) Margie Salgado Mata, Linda Gómez, and Anita Belásquez Andrews.

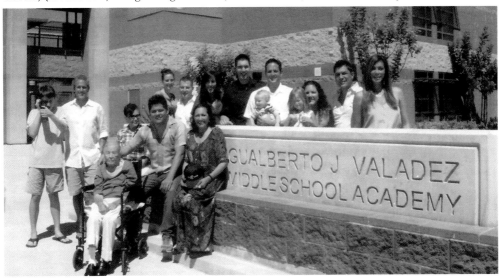

Gualberto J. Valadez Middle School Academy in Placentia opened its doors in 2008. It was named for beloved educator, coach, and civic leader Gualberto J. Valadez, who taught in the Placentia-Yorba Linda Unified School District from 1939 to 1983. His wife, Cecilia (first row, left to right), age 96, is pictured with daughter Nora Valadez, grandson Adrian Olmos, and daughter Ines Maria Scipe as well as numerous other grandchildren and great-grandchildren. (Courtesy of Susan C. Luévano.)

The La Habra Aces were an all-girls' softball team that played from 1947 to 1951. Former Aces players, from left to right, Rosie Gómez (first base), Amelia Zúñiga (pitcher), Rachel Zúñiga (catcher), and Frank H. Zúñiga (batboy) are pictured. The team integrated players from all three La Habra barrios making them popular with the entire community. These women recalled that even though it was the first organized team they had ever played for, they had a really strong group of women athletes. (Courtesy Susan C. Luévano.)

Former major league pitcher and renowned baseball scout Jesse Flores, who lived in La Habra from 1923 until his death in 1991, began playing sandlot baseball when he was a child at what is now Portola Park. Portola Park's three baseball fields where Jesse spent years developing baseball programs for local youth and adults were named the Jesse Flores Sports Complex in 1994. Jesse's godson Al Molina is pictured next to the plaque that honors this hometown hero. (Courtesy of Susan C. Luévano.)

Former players from the cities of Anaheim, Orange, Placentia, and Fullerton met June 27, 2011, to help with collecting photographs and to share stories. Pictured here at Kramer Park in Placentia are, from left to right, Carlos Felipe of Placentia, Frank Aguirre of Anaheim, José G. Felipe of Placentia, Ted Herrera of Orange, Frank Rangel of Placentia, Joe Juárez of Fullerton, Jim Segovia of Placentia, and Matt A. Encinas of Porterville. (Courtesy of Richard Santillán.)

Art (left) and Bob Lagunas are seen here in 2010 at California State University at Los Angeles where they played in 1959 and 1960. They were also teammates at Orange Coast College during the late 1950s. During the 1950s and 1960s, they were considered one of the best double-play combinations in the state of California.

Ray R. Reyes and Edward Castro are pictured, from left to right, wearing their La Jolla Junior High Varsity letterman sweaters. Ray, who graduated in 1942, was a member of the first baseball team organized by Coach Valadez in 1939. Edward and his brother Leo, who graduated in 1944, shared their coveted sweater. This was necessary, as the family could not afford to buy two sweaters. Back in the day, the families bought the sweater, and the school provided the letter. (Courtesy of Susan C. Luévano.)

Rosie Gómez (far left) played softball in the late 1940s and early 1950s for the La Habra Aces. Her great-granddaughters Jayanna Pérez (far right) and Mariah Gómez Carcano (second from left) have carried on the softball tradition. Jayanna plays year-round on Team USA, and Mariah plays for the city of Brea. The girls were inspired and proud of their great-grandmother after seeing team photographs of the Aces in the softball uniforms. Jayanna and Mariah see their great-grandmother as one of them! (Courtesy of Max Molina.)

Joe Juárez and Frank Muñoz have been best friends ever since they were nine years old. They played baseball together from elementary school through college and with the Eastside Athletic Club. Both men served in the South Pacific at the same time during World War II. Joe was in G Troop, 12th Cavalry, 1st Division of the Army, and Frank was in the 503rd Regimental Combat Team Airborne, one of the most decorated units of its kind in World War II. (Courtesy of Susan C. Luévano.)

The Anaheim Tigers claimed Boysen Park in Anaheim as home field in the 1950s. The winning Tigers played exclusively on Sundays and consisted of Mexican American players hailing from Placentia and Anaheim. The postmaster, who fielded an Anglo team, resented the Tigers and tried various tactics to rid Boysen of them. With his derision barely hidden, he tried negotiating for their departure by offering José G. Felipe baseballs, then bats, and finally money until he proffered a successful rule to the City of Anaheim declaring that teams claiming Boysen for home field, must prove each player was an Anaheim resident. Felipe revisited the old park in September 2012. (Courtesy of Monica DeCasas Patterson.)

Many barrios and colonias hold annual reunions to renew old friendships and share the *recuerdos* of the past, allowing for multiple generations to intermingle. This photograph, taken September 2012, shows, from left to right, Carmen Luna, Mary García, and Helen Parga Moraga at Chepa's Park in Santa Ana, named after an important community activist. Mary García is shown holding her book on Logan Barrio history. (Courtesy of Angelina Veyna.)

The sons and daughters of Tom Muñoz are pictured in front of "Muñoz Place," a street named after their father, in the Legends housing track, for his contribution to Placentia's amateur and semiprofessional baseball. His children are, from left to right, (first row) Rosie, Emilia, Angie, and Mary; (second row) Thomas and Jon. Sons Gilbert and Danny, now deceased, played for the Placentia Merchants under their father's leadership. Amongst other honors bestowed onto Muñoz, the City of Placentia celebrated his accomplishments at Angel Stadium, where a party was held in his honor and he threw the ceremonial first pitch in 1990. (Courtesy of Luis F. Fernández.)

Sons and daughters of Tom Muñoz, along with a small portion of three generations of grandchildren, stand in front of the scoreboard of the Tom Muñoz Baseball Field at Placentia Champions Sports Complex. As a testimony of Muñoz's contribution to baseball, the City of Placentia proclaimed August 28, 1990, to be "Tom Muñoz Day," and he received the key to the city for his lifetime devotion to community baseball and for being an exemplary role model for sportsmanship and integrity. One could say, that this field, dedicated in Muñoz's honor, is his "field of dreams." (Courtesy of Luis F. Fernández.)

BIBLIOGRAPHY

Arellano, Gustavo. "Grove of Dreams: The Life and Times of Orange Picker-Turned-Big-Leaguer Jesse Flores." *OC Weekly*. April 5, 2007.

———. "Gunkist Oranges." *OC Weekly*. June 8, 2006.

———. *Orange County: A Personal History*. New York: Scribner, 2008.

Arriola, Christopher J. "Knocking on the Schoolhouse Door: Méndez v. Westminster, Equal Protection, Public Education, and Mexican Americans in the 1940s." *La Raza Law Journal* 8:2 (Fall 1995): 166–207.

Edward M. "Eddie" Castro, interview by Jeanette Gardner, Placentia, CA: Placentia Historical Committee, January 14, 2009.

Epting, Chris. *Baseball in Orange County*. Charleston, SC: Arcadia Publishing, 2012.

Garcia, Mary. *Santa Ana's Logan Barrio: Its History, Stories, and Families*. Santa Ana, CA: Santa Ana Historical Preservation Society, 2007.

González, Gilbert G. *Labor and Community: Mexican Citrus Worker Villages in a Southern California County, 1900–1950*. Urbana, IL: University of Illinois Press, 1994.

Green, Mary. *La Habra, the Good Old Days: A Special History & the Way it Was: As Told by Our Early Settlers*. La Habra, CA: La Habra Children's Museum, 1983.

Lopez Schlereth, Rosie. *Hi! My Name is Chicken: A Life Story*. Anaheim: personal publication, 2010.

A Placentia Disaster: The 1938 Flood as Remembered by Mr. Eddie Castro. Directed by Placentia Library District, Edward M. Castro, and Gary Bell. Orange, CA: Innovative Media Productions, 2007.

Romero, Robert Chao, and Luis F. Fernández. *Doss v. Bernal: Ending Mexican Apartheid in Orange County*. Chicano Studies Research Center, University of California, Los Angeles. No. 14.

Santillán, Richard A., Mark A. Ocegueda, and Terry A. Cannon. *Mexican American Baseball in the Inland Empire*. Charleston, SC: Arcadia Publishing, 2012.

LATINO BASEBALL HISTORY PROJECT ADVISORY BOARD

Advisory board members for the Latino Baseball History Project at California State University, San Bernardino include the following:

José M. Alamillo, associate professor, California State University, Channel Islands
Gabriel "Tito" Avila Jr., founding president and CEO, Hispanic Heritage Baseball Museum, San Francisco
Francisco E. Balderrama, professor, California State University, Los Angeles
Tomas Benitez, artist and art consultant
Raúl J. Cordoza, dean, Los Angeles Trade-Technical College
Peter Drier, professor, Occidental College
Luis F. Fernández, public historian
Robert Elias, professor, University of San Francisco
Jorge Iber, associate dean and professor, Texas Tech University
Susan C. Luévano, librarian, California State University, Long Beach
Amanda Magdalena, doctorate student in history, University at Buffalo, the State University of New York
Douglas Monroy, professor, Colorado College
Carlos Muñoz Jr., professor emeritus, University of California, Berkeley
Mark A. Ocegueda, doctorate student in history, University of California, Irvine
Samuel O. Regalado, professor, California State University, Stanislaus
Anthony Salazar, Latino Baseball Committee, Society of American Baseball Research
Richard A. Santillán, professor emeritus, California State Polytechnic University, Pomona
Carlos Tortolero, president, Mexican Fine Arts Center Museum, Chicago
Sandra L. Uribe, professor, Westwood College, South Bay Campus, Torrance, California
Angelina F. Veyna, professor, Santa Ana College

Discover Thousands of Local History Books Featuring Millions of Vintage Images

Arcadia Publishing, the leading local history publisher in the United States, is committed to making history accessible and meaningful through publishing books that celebrate and preserve the heritage of America's people and places.

Find more books like this at
www.arcadiapublishing.com

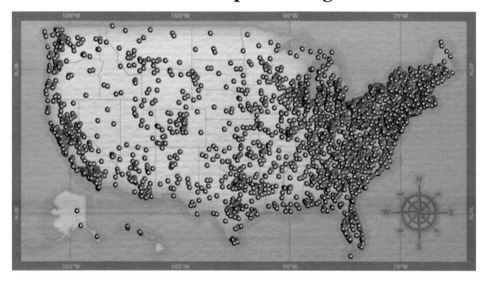

Search for your hometown history, your old stomping grounds, and even your favorite sports team.

Consistent with our mission to preserve history on a local level, this book was printed in South Carolina on American-made paper and manufactured entirely in the United States. Products carrying the accredited Forest Stewardship Council (FSC) label are printed on 100 percent FSC-certified paper.